OXFORD

A VIEW FROM THE PAST

ROBERT S. BLACKHAM

The History Press

First published 2009

The History Press
The Mill, Brimscombe Port
Stroud, Gloucestershire, GL5 2QG
www.thehistorypress.co.uk

British Library Cataloguing in Publication Data.
A catalogue record for this book is available from the British Library.

ISBN 978 0 7524 5128 2

Typesetting and origination by The History Press
Printed in Great Britain

CONTENTS

OXFORD
A VIEW FROM THE PAST

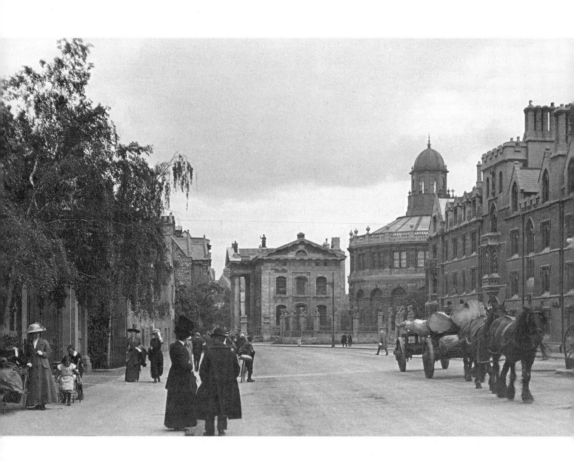

INTRODUCTION

I first went to Oxford in 2004 to visit my daughter who was living there at the time and, being a fan of the author J.R.R. Tolkien, we went to a number of the sites and buildings that related to his time in and around the city. I finished up writing a book about his life there, *Tolkien's Oxford*.

I can still remember the thrill the first time I turned into Broad Street from Parks Road and had my first view of a wealth of wonderful buildings adorned with fine sculptures. It was strangely quiet for Oxford, being just before Easter and the students were away, and there was Blackwell book shop. I still have one of my father's books which was sent to him from there when he was a prisoner of war in the Second World War. Over the next few years I visited the city in connection with Tolkien and stayed at a number of colleges, and I think the place must have got into my blood, so I put this book together so others could see a time mostly before the age of the engine-powered bus and mass ownership of the motor car.

The book is set out as six walks, not all of the same length, and covers many of the major buildings, roads and streets and the centre of Oxford. You can use it as a walking guide or travel around Oxford in your armchair in the comfort of your own home.

Oxford does not appear to have been a town in the Roman period, but there is evidence for industrial activity such as pottery production from this period. Its foundation appears to start in the Anglo-Saxon period with the establishment of a monastery in around AD 700 by a Saxon princess called Frideswide, and a small settlement starting to grow around the monastery adjacent to the ox ford across the Thames. Hence the settlement became known as Oxford. The monastery was located where Christ Church College and the Cathedral are today.

The town expanded through the Anglo-Saxon period and still has one surviving building from the eleventh century, St Michael at the North Gate. The Normans arrived in 1071 and Robert d'Oilly had the motte and bailey castle built.

During the twelfth century a university came into being. Colleges started to be set up, many from very humble beginnings with a dozen or so students and usually for religious teaching of students from different areas of England.

Oxford went through the Tudor period and the turmoil of the Reformation and during this period Brasenose, Corpus Christi, Christ Church (originally Cardinal), Trinity, St John's and Jesus colleges were founded.

In the Stuart period, Wadham and Pembroke colleges were founded and Oxford became the capital of Charles I, and after the Restoration the city expanded beyond its town wall and Wren built the Sheldonian Theatre on The Broad, now Broad Street.

The eighteenth century was a period of wonderful architecture, reaching its high point with the building of the Radcliffe Camera, one of the crowning glories of the Oxford skyline.

The nineteenth century saw much construction and rebuilding of colleges, and redevelopment of the main streets and roads within Oxford. The railway arrived in the

1840s and this must have made reaching the city much easier, especially for the student population. Another change was the arrival of the ladies-only colleges in the 1870s, Lady Margaret Hall and Somerville College.

The twentieth century brought the two World Wars, more building and rebuilding, new colleges and finally unisex education in the colleges. Time will be the judge of some of the buildings from the second half of the twentieth century.

I sometimes stand in the streets of Oxford and try to visualize the view from past centuries, and the vision that I see is of masons, carpenters, horse-drawn wagons loaded with stone and timber, students, professors and townsfolk. Possibly with a group of people grumbling about the new buildings being built and how they will not fit in. Probably it's the same today but without the horses.

Finally I would like to thank Oxford and all the people who helped put this snapshot of the city together.

1

NORTH OXFORD

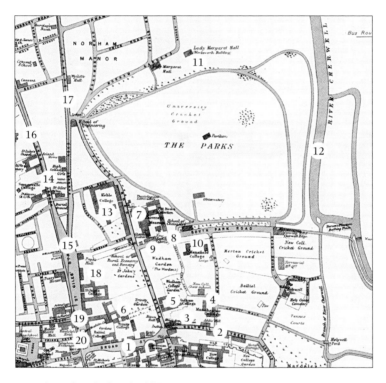

Map of North Oxford in the 1920s.

Map Key
1 Broad Street
2 Holywell Street
3 Holywell Music Room
4 Manchester College
5 Wadham College
6 Trinity College
7 University Museum
8 South Parks Road
9 Rhodes House
10 Mansfield College
11 Lady Margaret Hall
12 River Cherwell
13 Keble College
14 Somerville College
15 St Giles
16 Woodstock Road
17 Banbury Road
18 St John's College
19 Martyrs' Memorial
20 St Mary Magdalene

BROAD STREET or THE BROAD

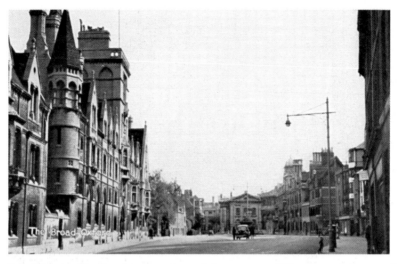

Broad Street or The Broad as it was formerly known started life as part of the town ditch beyond the city wall. As the colleges in Oxford grew and the town wall came down in this area it became Broad Street, and we can still see today many of the fine buildings on it. It had a darker side in the sixteenth century, as we will see later on.

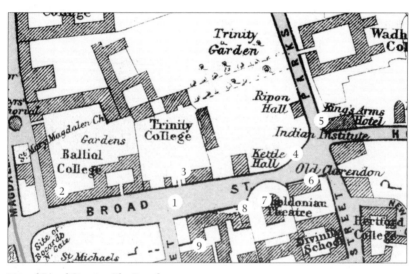

Map of Broad Street or The Broad

Map Key
1 Broad Street
2 Balliol College
3 Trinity College Gateway
4 New Bodleian Library
5 King's Arms Hotel

6 Clarendon Building
7 Sheldonian Theatre
8 Old Ashmolean Building
9 Exeter College

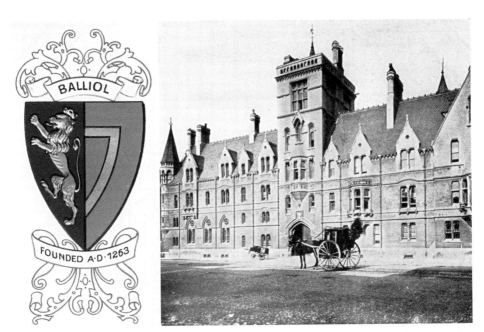

Balliol College was founded by John de Balliol, who had many estates in England and France. The foundation date is believed to be in the 1260s, when he rented a house in Oxford for a group of poor students as a penance for kidnapping the Bishop of Durham. The current college arms dates from about 1900 and is made up on the left-hand side by the Lion of Galloway, and on the right-hand side by half of the college arms used between 1600 and 1850.

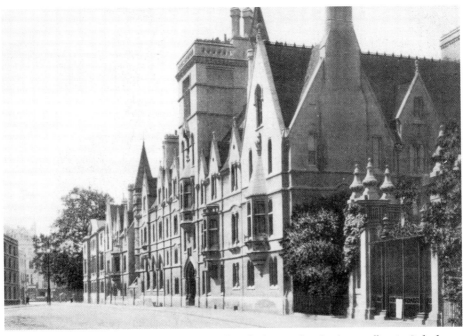

Balliol College is at the start of Broad Street and has the longest façade of any college in Oxford, stretching along Broad Street and round the corner along St Giles' Street.

The simple stone cross in Broad Street marking the place where in the 1550s Thomas Cranmer, Nicholas Ridley and Hugh Latimer were burnt at the stake. The memorial to them is round the corner in St Giles' Street and is called the Martyrs' Memorial.

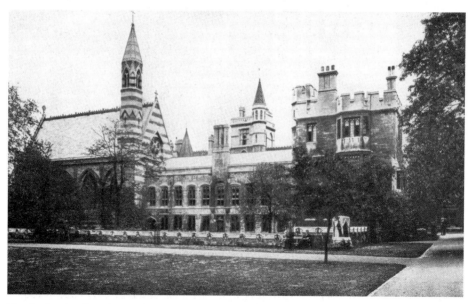

The Garden Quadrangle at Balliol College. The college was a strong supporter of Rome during the Reformation and tried to resist Henry VIII's supremacy over the Pope in the 1530s.

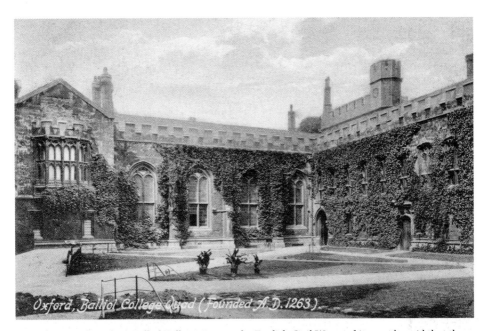

The Front Quadrangle at Balliol College. During the English Civil War, and it must be said that there was nothing at all civil about it; the college had to support Charles I. The college had to lend the king £210, a huge sum of money at the time, and all its domestic silver, worth £334. This debt has never been repaid to date and would be a huge sum of money today.

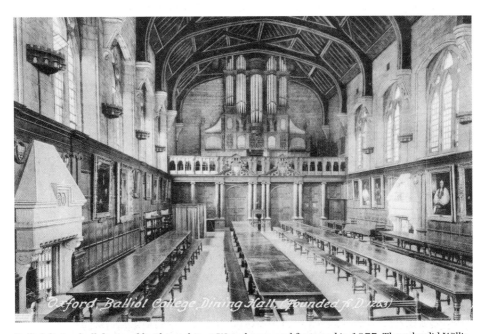

Balliol dining hall designed by the architect Waterhouse and first used in 1877. The splendid Willis Organ cost between £1,000 and £2,000 depending on which source you take. The oak panelling was added in 1911 and is Jacobean in style. Below the hall is a buttery, common room, laboratory and the kitchen, with the food being take up to the hall by a lift.

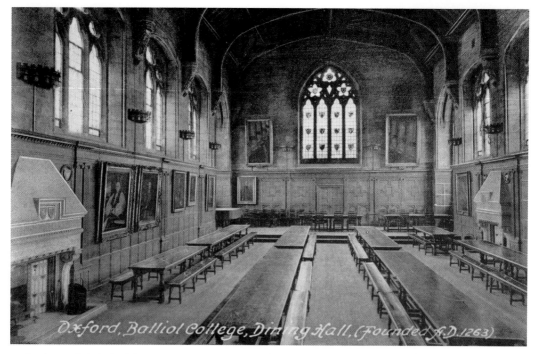

At the dais end of the hall there are two fine paintings of John de Balliol and his wife Dervorguilla of Galloway, who on John's death in 1269 provided a capital endowment for the college and is considered to be a co-founder of the college.

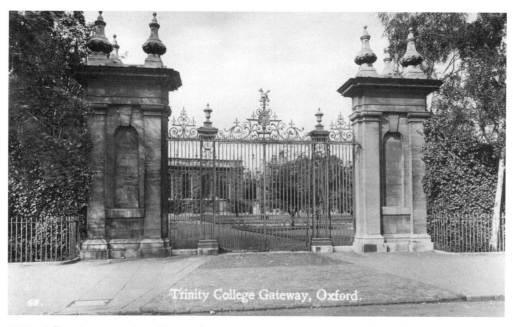

Trinity College Gateway on Broad Street. There is a story that this gateway will be never be opened until there is a Stuart on the throne of England. There is pedestrian access to the college to the right of the gateway as the Parks Road gateway is closed.

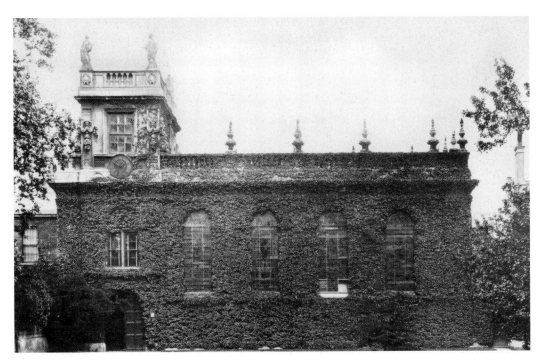

Trinity College Chapel lies well back from Broad Street. It was completed in 1694 and the screen and altar-piece are beautiful wood-carvings by Grinling Gibbons. The gate tower on the left of the picture is crowned by statues of Geometry, Astronomy, Theology and Medicine.

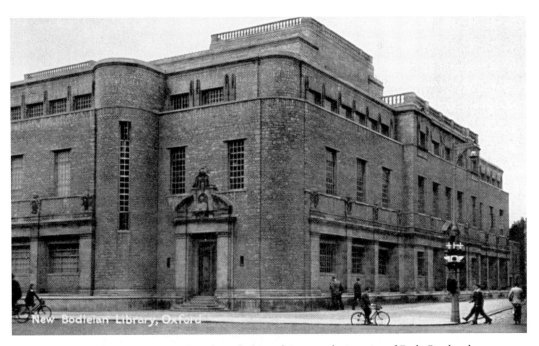

The New Bodleian Library stands at the end of Broad Street at the junction of Parks Road and was designed by Sir Giles Gilbert Scott, the designer of the red telephone box.

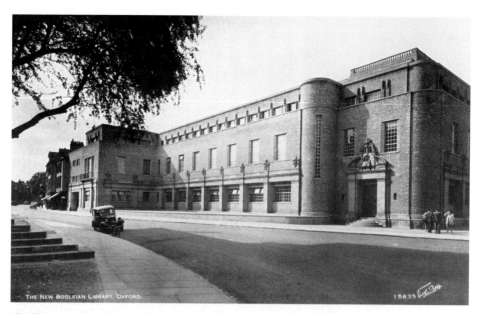

The library was built from 1937–40 but was not officially opened until 1946. It is not open to the public and is linked to the original Bodleian Library in Catte Street by an underground tunnel.

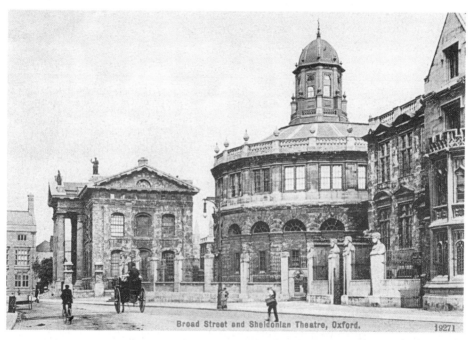

Moving from left to right on the picture above; on the far left is the King's Arms Hotel, Clarendon Building, Sheldonian Theatre with the rear of the building sticking out into Broad Street like the stern of a ship, and the Old Ashmolean Museum. The Old Ashmolean building was built of Headington stone between 1679–83, and was opened by the Duke of York, who was to become James II. It cost around £4,500 to build, a huge sum of money at the time, and housed a collection of natural curiosities that had been collected by John Tradescant the Younger. It was inherited by Elias Ashmole, hence its name.

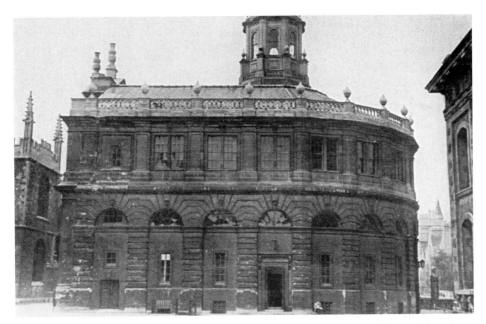

The Sheldonian Theatre was built 1664–69 and was the first building designed by Sir Christopher Wren, who at the time was a Professor of Astronomy at Oxford. It was commissioned by Gilbert Sheldon, hence its name, and he provided the £14,500 towards its building. He later went on to be Chancellor of the University in 1667. The Oxford University Press used the attic as a print room until 1713, when it moved to the Clarendon Building next door.

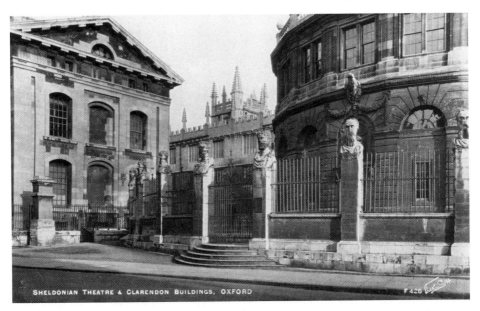

SHELDONIAN THEATRE & CLARENDON BUILDINGS, OXFORD F 428

The end of the Clarendon Building can be seen on the left-hand side of the photograph, with the Divinity School and Bodleian Library in the centre and the rear of the Sheldonian Theatre on the right-hand side.

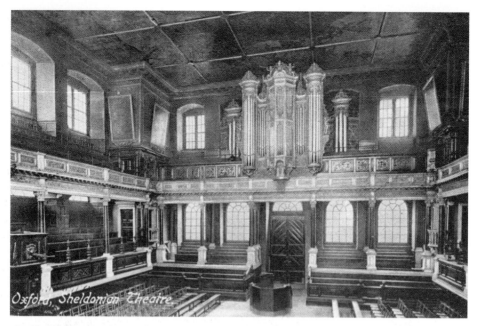

The Sheldonian Theatre is used for degree ceremonies and the ceiling was painted by Robert Streeter to appear to be open sky, showing the victory of science and art over ignorance. This picture dates from around 1905.

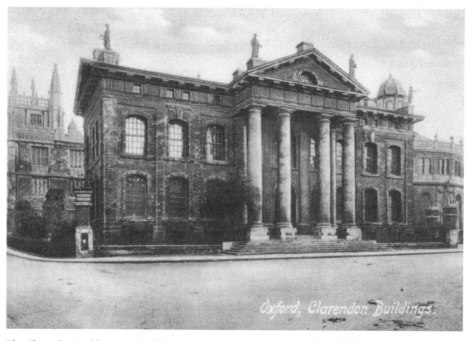

The Clarendon Building was built between 1711-15 to house the Oxford University Press. It was known as 'The Print House' until 1832 when the Press moved out, but part of it was used by the University Police in 1832, with cells in the basement. In the early part of the twentieth century it was university offices and is now part of the Bodleian Library.

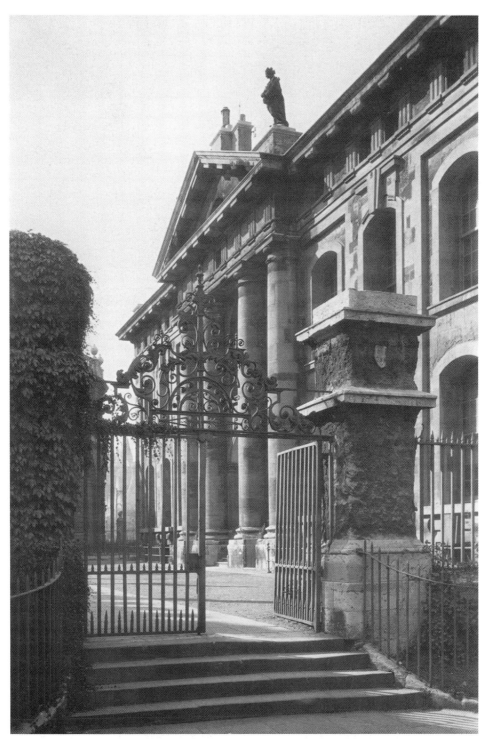

The elegant wrought-iron gates are by Jean Tijou and the nine statues on the upper part of the building are by James Thornhill. Only one can be seen in this photograph, and sadly the gates are no longer in situ.

HOLYWELL STREET TO ST GILES VIA LADY MARGARET HALL

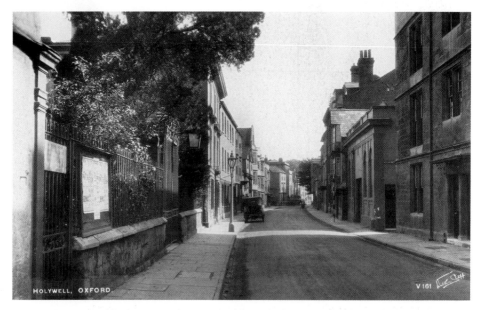

Looking down Holywell Street from outside the Holywell Music Room, built between 1742–48, and which is said to be the first building built for musical performance in England. Holywell Street comes off the end of Broad Street and runs down to Long Wall Street.

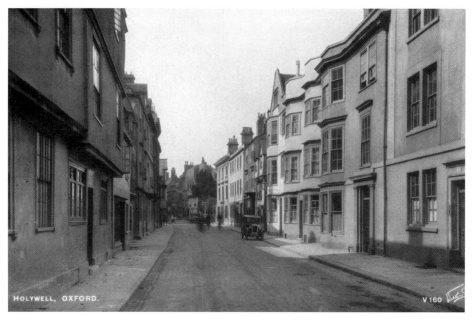

Looking up Holywell Street towards the Broad Street end from the junction with Mansfield Road. Holywell Street was mostly built in the seventeenth century when Oxford started expanding outside the town wall after the Black Death.

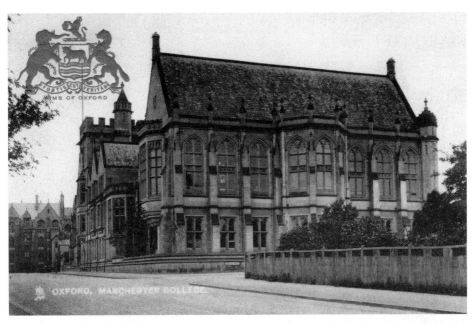

Manchester College stands on the Mansfield Road at the junction with Savile Road and was originally founded in Manchester in 1786 before moving to Oxford in 1889. The view in the picture above is of the library with its fine oriel window at the centre of the building.

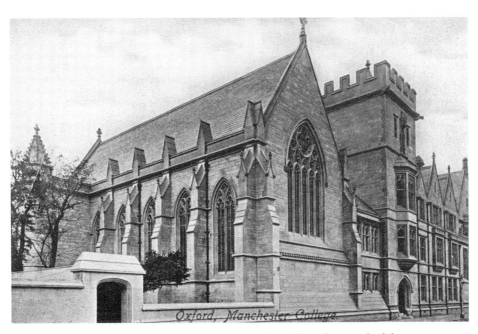

Its primary role is theological training of Unitarian students. The college was built between 1891–93 and the architect was Thomas Worthington of Manchester. Today the college is known as Harris Manchester following extensive donations from Philip Harris, the founder of Harris Carpets.

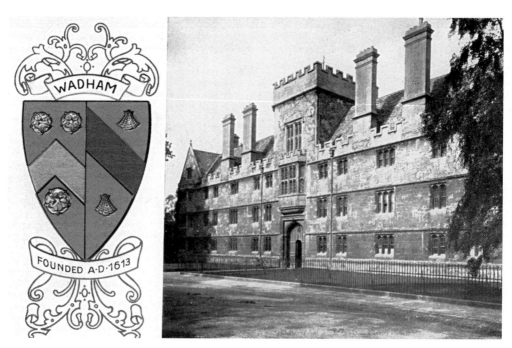

Wadham College was founded by Nicholas and Dorothy Wadham from Merifield in Somerset in 1610 and the original buildings were completed by 1613. They were wealthy land owners in Somerset.

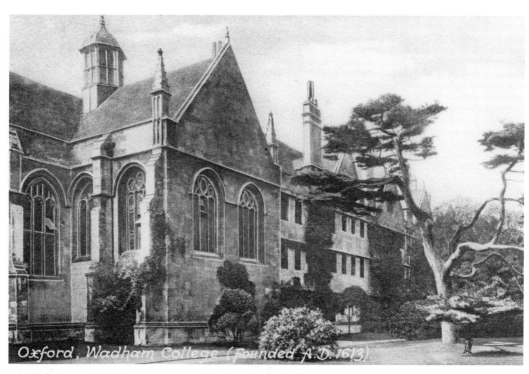

Wadham College garden, said to be one of the best in Oxford, was constructed in 1796 and is still in the original form that the garden planners laid out over 200 years ago.

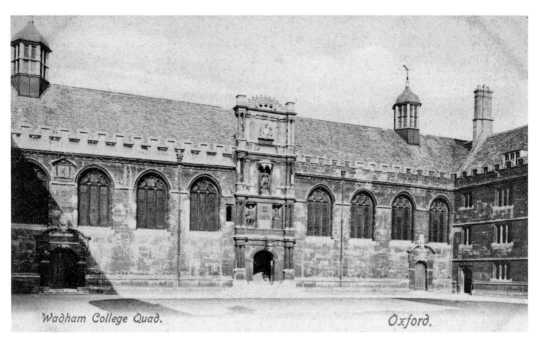

Wadham College Quad. Oxford.

Wadham College Front Quadrangle, shown above, is entered via Parks Road and is the main body of the original college, built in a conservative Gothic style.

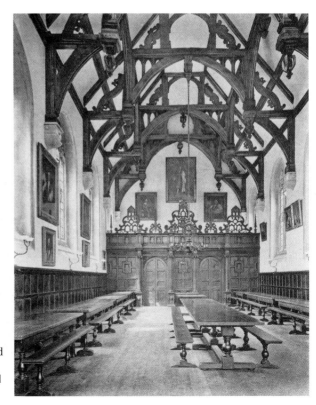

The Great Hall at Wadham has a wonderful hammer-beam roof and is entered via a Jacobean wooden entrance screen, shown at the end of the hall in the picture above.

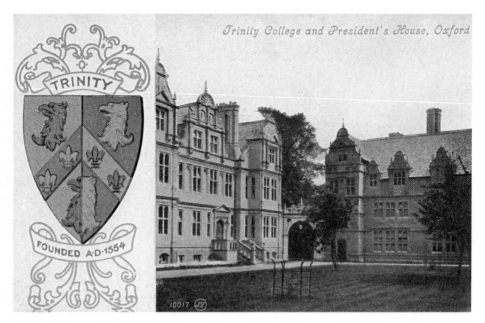

Trinity College was founded by Sir Thomas Pope, an Oxfordshire man, in 1555. The college is built on the site of Durham College, founded in 1286 for the education of monks from the Cathedral Church of Durham Cathedral. Pictured above is Kettell Hall, built between 1618–20 by Ralph Kettell, President of Trinity, as a private house.

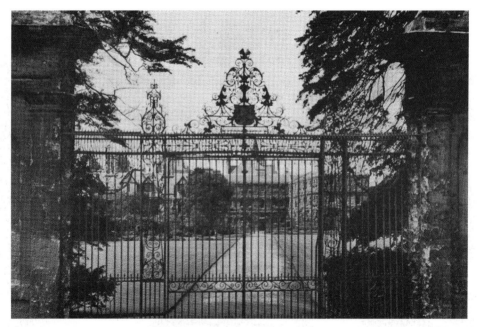

Trinity College gateway on Parks Road looking into the Garden Quadrangle. Thomas Pope was the Treasurer of the Court of Augmentations and its duty was to dissolve the monasteries' estates for Henry VIII but he later went on to be a councillor for Mary, the Roman Catholic Queen of England. He received agreement for the founding of Trinity College from her. This gateway is now closed by a low wall on the road side of the gateway.

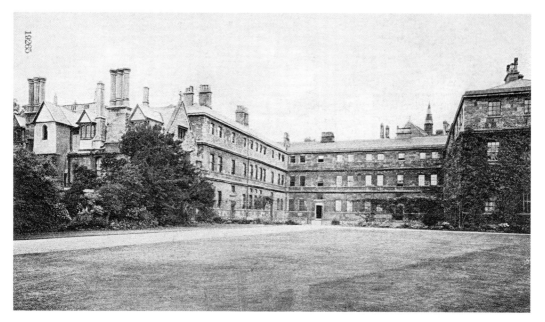

Trinity College Garden Quadrangle. This is the view you would have if you had walked through the gates on Parks Road. The quadrangle buildings were started by Sir Christopher Wren in 1668 with further ranges added over the years.

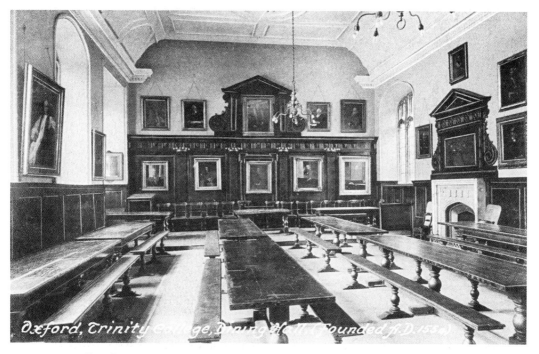

Oxford, Trinity College, Dining Hall (Founded A.D. 1554)

Trinity College dining hall was built between 1618–20 and is said to be the most modest of all the early college halls. The coved stucco ceiling dates from 1772 and the Gothic fireplace dates from 1846. The view above is looking towards the dais end of the hall.

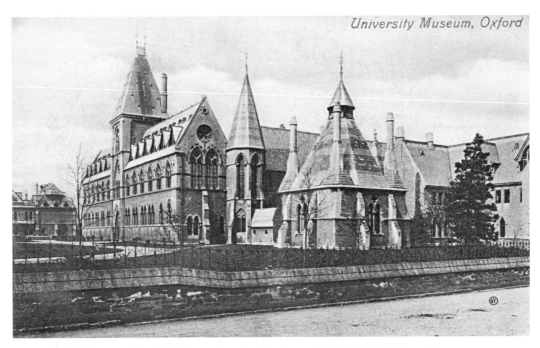

University Museum stands on Parks Road and was built between 1855–60. The building that we see today was one of thirty-two designs that were offered in a design competition in 1853. The museum houses science and natural history displays.

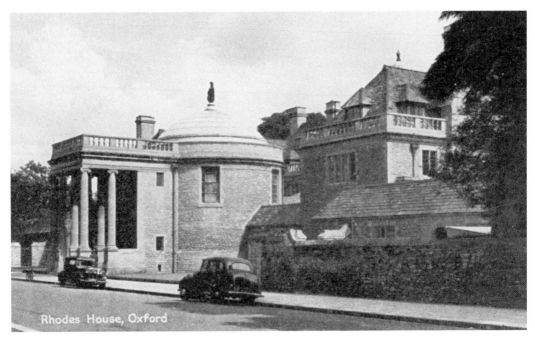

Rhodes House, Oxford

Rhodes House stands on South Parks Road and money for its construction was left in Cecil Rhodes's will. It was started in 1929 and the building is in two different styles, a Cotswold mansion and a classical domed rotunda. It was for students from the United States, the British Empire and Germany.

Mansfield College started life as Spring Hill College in Birmingham in 1838, moving to a new building in Moseley, Birmingham in 1857, also known as Spring Hill College. It moved to Oxford in 1886 and became Mansfield College, named after the Mansfield family that founded Spring Hill College.

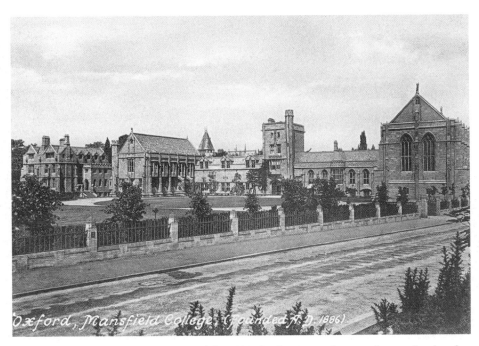

The college was built 1887–89 at a cost of £40,000. On the picture above can be seen the chapel on the right-hand side and in the centre the gate tower, but there is no access from it. The tower is very similar in design to the original one in Moseley.

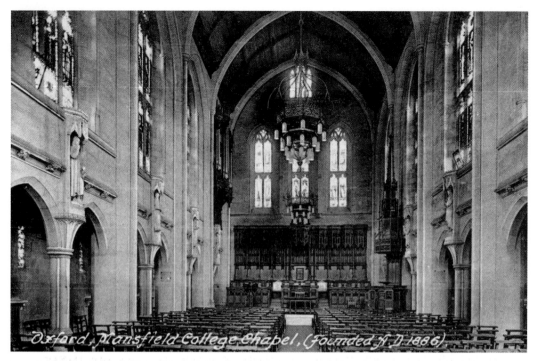

Oxford, Mansfield College Chapel, (Founded A.D. 1886)

Mansfield College Chapel. The college is primarily a theological training college for Congregationalists and comes from a long tradition of Nonconformists and Quakers in Birmingham.

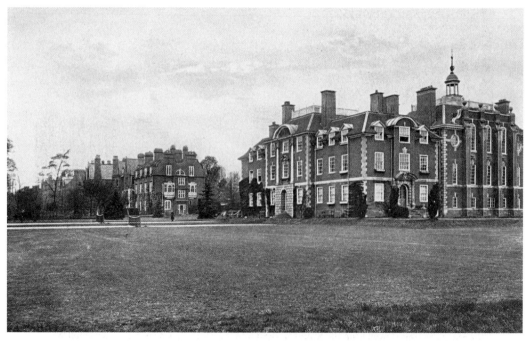

Lady Margaret Hall. On the right of the picture is the rear of the Talbot Building and the Wordsworth Building, built in 1896. On the left of the picture are the New Old Hall and the Old Old Hall.

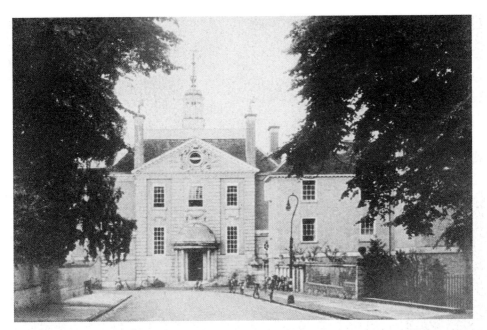

Lady Margaret Hall - looking at the Talbot Building, built between 1909-10, from Norham Gardens. The roadway in front of the building is now the Wolfson Quadrangle. The college stands on the north side of University Parks in one of Oxford's leafy suburbs and was founded in 1878 for young ladies to be prepared for university examinations.

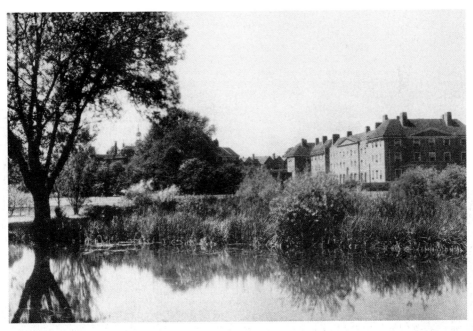

Lady Margaret Hall viewed from the River Cherwell and the 1931 Deneke Building, designed by Sir Giles Gilbert Scott. The college takes its name from Lady Margaret, the mother of Henry VII and founder of the Tudor dynasty.

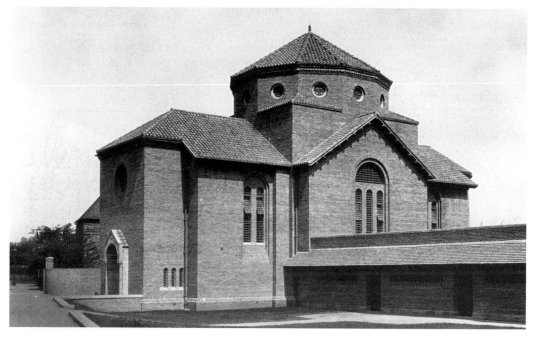

Lady Margaret Hall Chapel, also designed by Scott in Byzantine style, is connected to the Benson Place by the long gallery on the right-hand side of the picture.

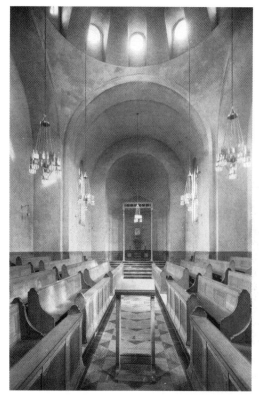

The inside of Lady Margaret Hall Chapel is in the style of Ostberg from the 1925 Paris Exhibition.

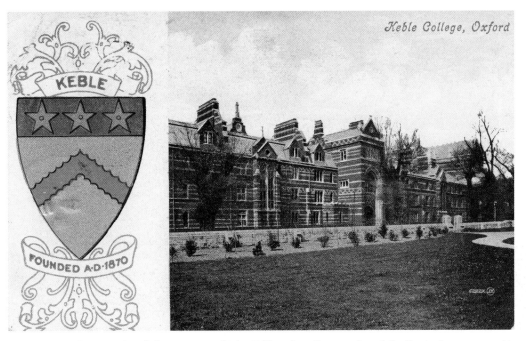

Keble College was founded in memory of John Keble, a founding member of the Tractarian movement in the nineteenth century. The college building was funded by Tractarian supporters and took its first thirty students in 1870.

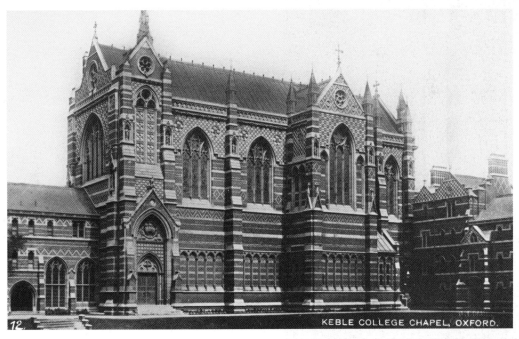

The chapel in the picture above is on the corner of Parks Road and Keble Road. The college buildings are built mostly in red brick but the use of coloured brick allows much decoration, such as banding and chequers, throughout the whole college buildings.

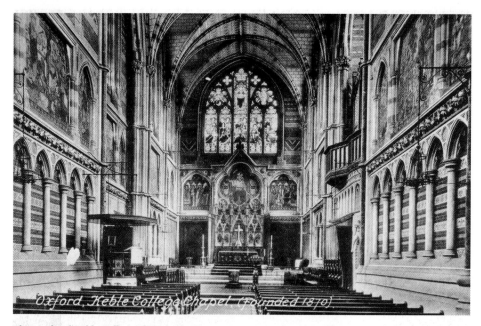

The inside of Keble College Chapel. The Tractarian movement wanted to restore the heritage of the Catholic Church to the Church of England and this can be seen in the highly decorated inside of the chapel. William Gibb, whose wealth came from the guano trade with the Pacific islands, paid for the chapel which was opened on St Mark's Day, 1876.

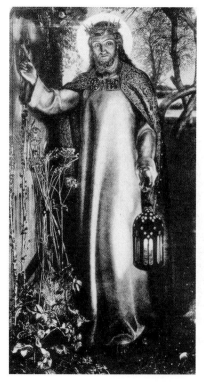

The Light of the World painting of Christ by Holman Hunt was presented to Keble Chapel by Mrs Martha Combe in 1873 and the lantern depicted in the painting was found hanging in a suburban house in 2001.

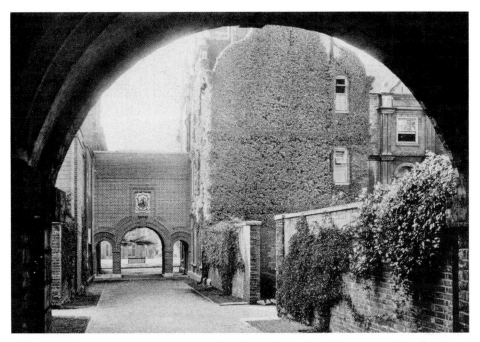

Somerville College was founded in 1879 as a college for women only. Women at the time were excluded from Oxford University colleges. It was named after Mary Somerville (1780–1872), the Scottish scientist and mother of five children. The view on the picture above is from the second archway of the main entrance on Woodstock Road.

Part of the Main Quadrangle at Somerville College, built in 1933 and designed by Morley Horder. The college became part of the University of Oxford in 1959 and the first male students were admitted in 1993.

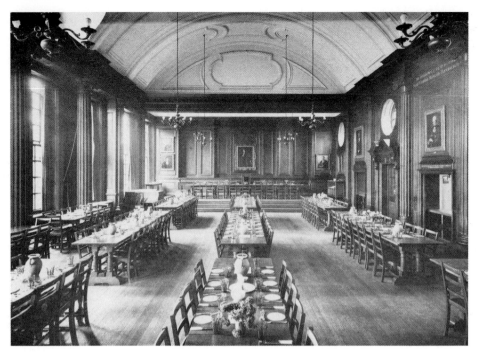

Somerville College Dining Hall, built 1912–13, is on the first floor and has wooden panelling and a tunnel-vaulted plaster ceiling. The picture above is looking towards the dais end of the hall.

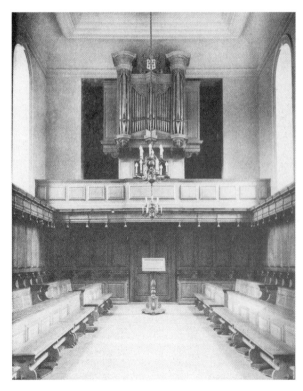

Somerville College Chapel was built in 1935 and has a wonderful simplicity in its design. The college was established as a non-denominational alternative to Lady Margaret Hall, which was Anglican.

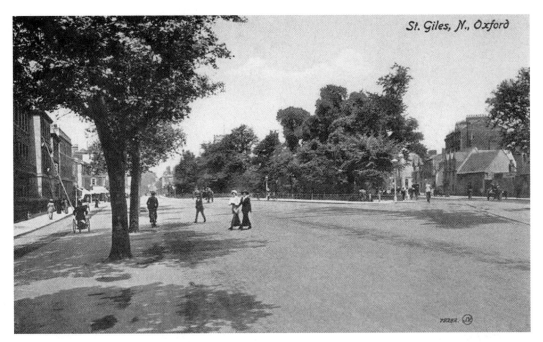

St Giles Street at the north end where it splits in two to become the Woodstock Road and Banbury Road. The picture above is from the very early part of the twentieth century.

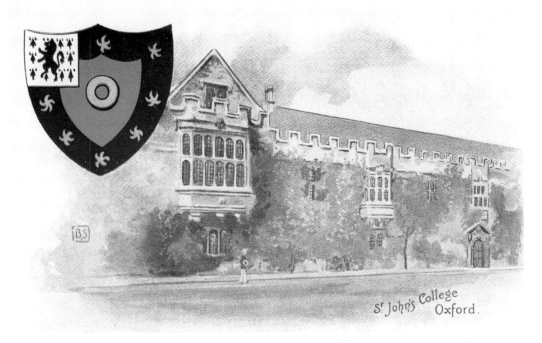

St John's College stands at the town end of St Giles Street. The college was founded by Archbishop Chichele in 1437 and was called St Bernard's College, being a house for Bernardine monks who were part of the Cistercian order. The college was dissolved in the Reformation.

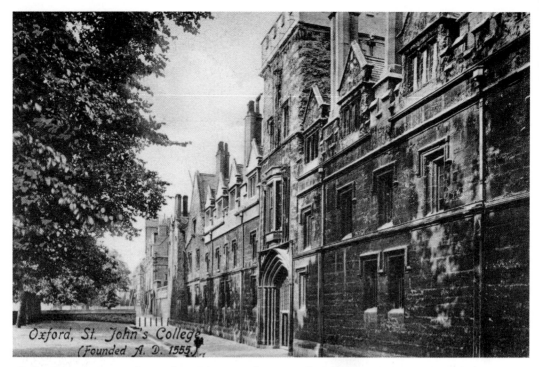

The façade on the picture above is that of the original St Bernard's College, facing onto St Giles Street. This is the front of the Front Quadrangle, built in the late fifteenth and early sixteenth centuries.

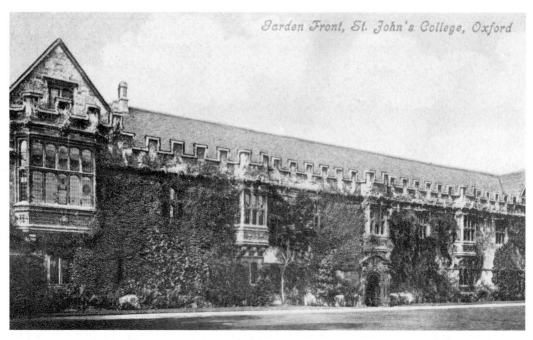

It became St John's College in 1555, being re-founded by Sir Thomas White, who was Master of the Merchant Taylors' Company, and wealthy citizens of London. John the Baptist is the patron saint of tailors.

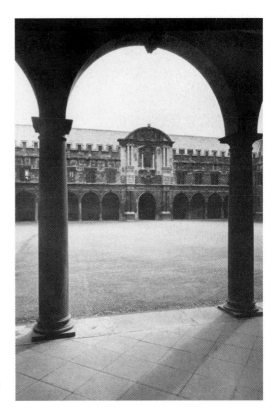

The Canterbury Quadrangle stands behind the Front Quadrangle and was built between 1631–36. To the side of the quadrangle is the wonderful college garden.

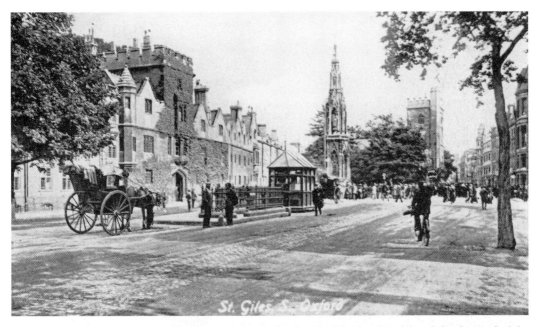

St Giles Street ends at the Martyrs' Memorial with the church of St Mary Magdalene behind it. To the left of the memorial is part of Balliol College. The picture dates from the late nineteenth or early twentieth century when Oxford was still a horse-drawn vehicle town.

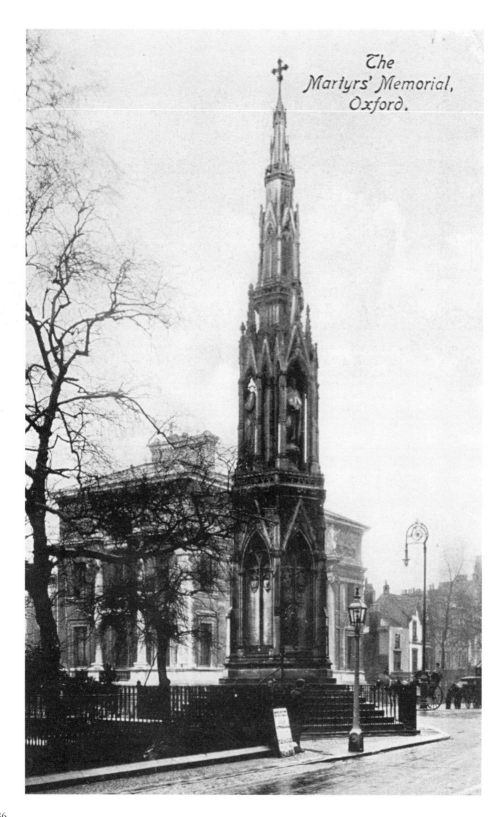

The
Martyrs' Memorial,
Oxford.

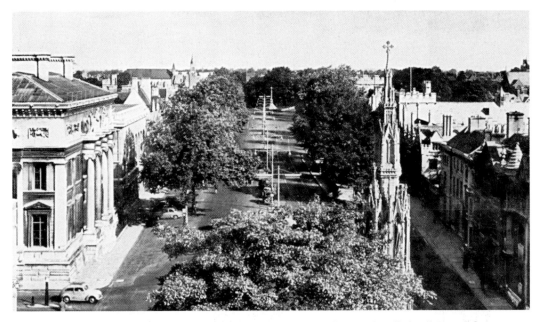

Looking down St Giles Street from the tower of St Mary Magdalene, with Balliol College and the
Memorial on the right-hand side and the Ashmolean Museum and Taylorian Institution, built between
1841–45, on the left-hand side.

Opposite: The Martyrs' Memorial was designed by Sir George Gilbert Scott and was completed in
1843. It commemorates the burning at the stake of Thomas Cranmer, Nicholas Ridley and Hugh
Latimer during the Catholic Queen Mary's reign in the sixteenth century. All three were leading
members of the Protestant Church. There was much religious turmoil in the 1840s between the
Catholic Church, the High Church of England (Tractarians) and the Low Church of England.
The monument was to remind people that the founders of the Church of England had been martyred
by the Roman Catholic Church. The Ashmolean Museum and Taylorian Institution can be seen
behind the memorial.

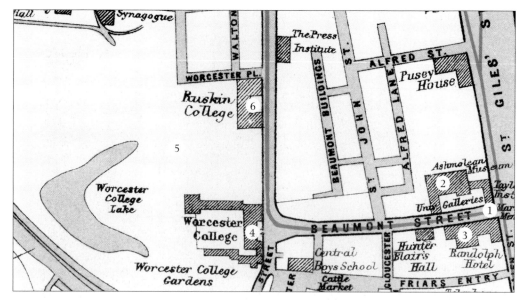

Map Key
1 Beaumont Street
2 Ashmolean Museum and Taylorian
 Institution
3 Randolph Hotel
4 Worcester College
5 Worcester College gardens
6 Ruskin College

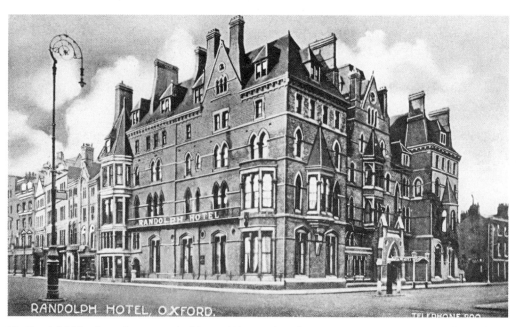

The Randolph Hotel stands opposite the Martyrs' Memorial on the corner of Beaumont Street and was built in 1864.

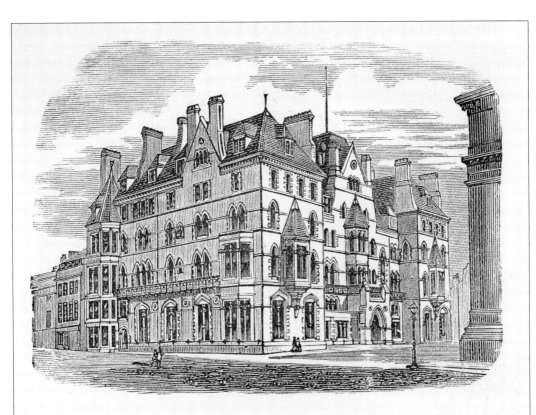

RANDOLPH HOTEL

IN THE CENTRE OF THE CITY.

THE MODERN HOTEL OF OXFORD. Near Colleges, Public Buildings, and opposite the Martyrs' Memorial. Every comfort and convenience. Handsome Suites of Rooms. Drawing Rooms. New Lounges. Smoking and Billiard Rooms. Garage adjoining. Night Porter in attendance.

UP-TO-DATE CENTRAL HEATING.

Electric Elevator. Moderate Charges. R.A C., and A.A.
Telephone No. 290 Oxford Address : THE MANAGERESS.

A stylish advert for the Randolph Hotel from the 1920s.

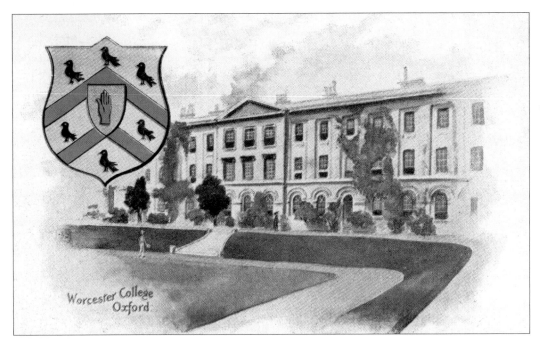

Worcester College stands at the junction of Beaumont Street and Worcester Street and started life as Gloucester College in 1283 as a college for Benedictine monks. In 1714 it became Worcester College following the death of Worcestershire landowner Thomas Cookes, who left the college £10,000.

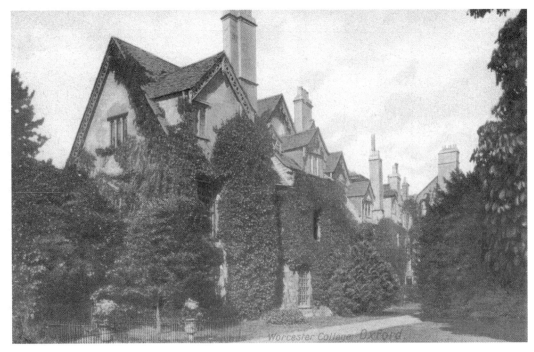

Part of the early college cottage row dating from the medieval period, this ivy-covered view is at the rear of the quadrangle where the cottages make up one arm of the quadrangle.

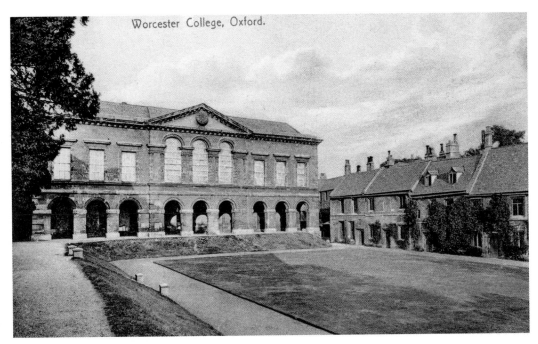

Worcester College, Oxford.

Worcester College Main Quadrangle. On the right-hand side are the early cottages and in the centre is the eighteenth-century Loggia Library building with its nine rounded arches (Loggia is a gallery open on one side, usually arched). Behind the library is the college chapel and hall.

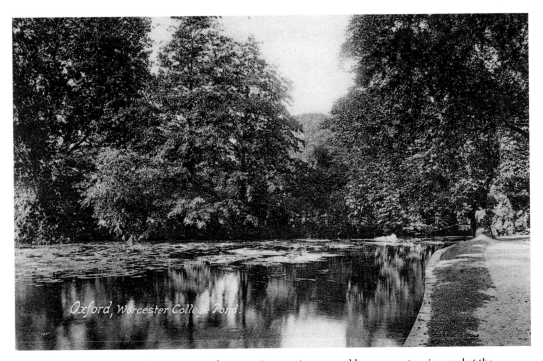

Oxford, Worcester College Pond.

Worcester College gardens are around twenty-six acres in area and have a great arcing pool at the far end, as shown above.

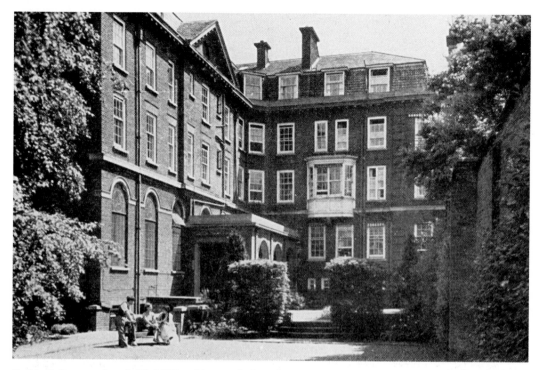

Ruskin College was founded in 1899 and is named after John Ruskin, the Victorian artist, art critic, amateur geologist, teacher, writer, social critic and philosopher. It was established to allow adults who did not have any formal qualification to study for a degree and one of its most notable students was John Prescott. It is not part of the University of Oxford but has close links with the university and some students, as part of their course, attend university lectures.

2

SOUTH OXFORD

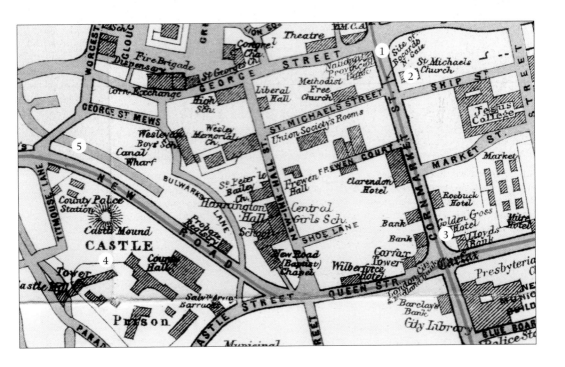

Map Key
1 Cornmarket Street
2 St Michael at the North Gate
3 The Golden Cross
4 Oxford Castle
5 Nuffield College

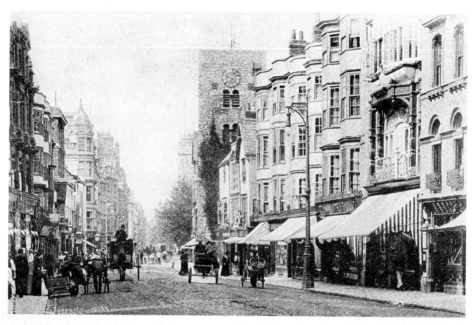

Cornmarket Street looking towards St Giles Street. The shops on the right-hand side of the picture have their awnings down to shade their customers from the summer sunshine.

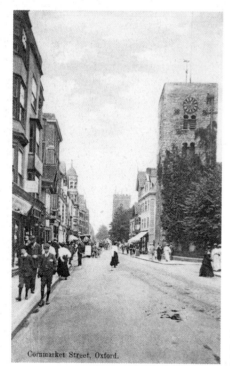

Cornmarket Street with the tower of St Michael at the North Gate first on the right-hand side, and in the distance the tower of St Mary Magdalen on Magdalen Street. The picture dates from the Edwardian period.

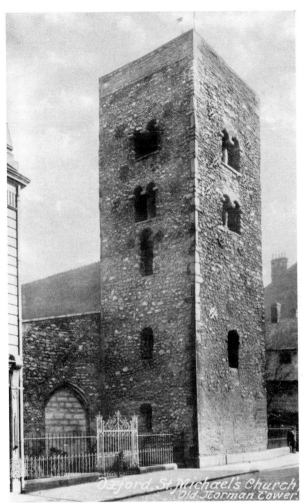

St Michael at the North Gate is so-called because it was located at the north gate of the city wall; it dates from 1040 and is Oxford's oldest surviving building, being Saxon in origin. The Oxford Martyrs were imprisoned in the nearby Bocardo Prison before being burnt at the stake on what is now Broad Street. William Morris, a leading member of the Pre-Raphaelite brotherhood and the Arts and Crafts movement, married Jane Burden of Holywell Street in the church on 26 April 1859.

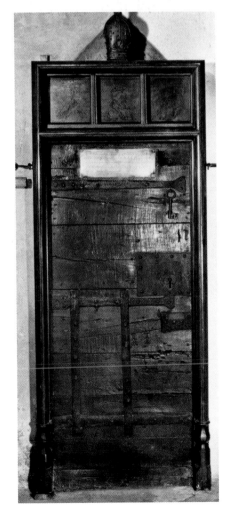

The cell door from Bocardo Prison where the Oxford Martyrs were held before being burnt at the stake in 1555 and 1556. It can be found on display in the church tower.

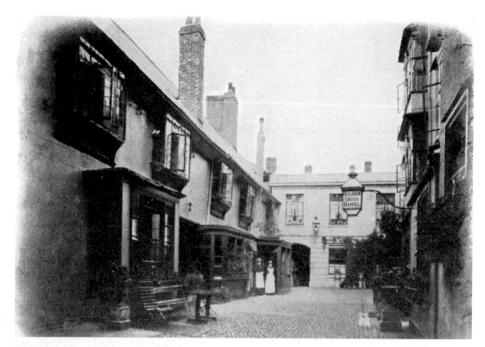

The Golden Cross was a traditional coaching inn and the building dates back to the fifteenth century, though a sign on the wall claims there was an inn there in 1182. Shakespeare's Company used the inn courtyard to perform *Hamlet* in 1593 and the Oxford Martyrs are said to have been held in the inn for a time.

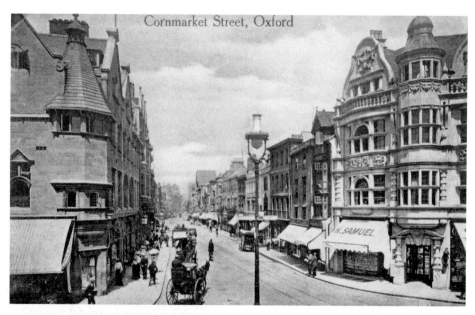

Cornmarket Street viewed from the junction with High Street, St Aldates Street and Queen Street, looking up towards St Giles Street. The street is lined with many fine Victorian and Edwardian buildings. Once again the shops on the right-hand side of the picture have their awnings down to shade their customers from the summer sunshine.

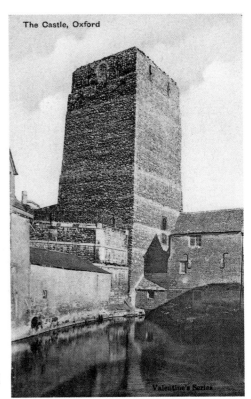

The Castle, Oxford

Valentine's Series

Oxford Castle dates back to 1071 when Robert d'Oily built a castle on the site for William the Conqueror. A prison was built within the castle in the thirteenth century. From 1613 until 1785 the prison was owned by Christ Church College. It closed in 1996 and was converted into a Malmaison Hotel.

In 1937 Oxford University approved the foundation of Nuffield College, which was to be the first postgraduate research college in Oxford. William Morris, Lord Nuffield, donated a £1 million endowment to the college. He was the founder of Morris Motors, which had a humble start in the 1890s when as a fifteen-year old he started repairing bicycles in a garden shed.

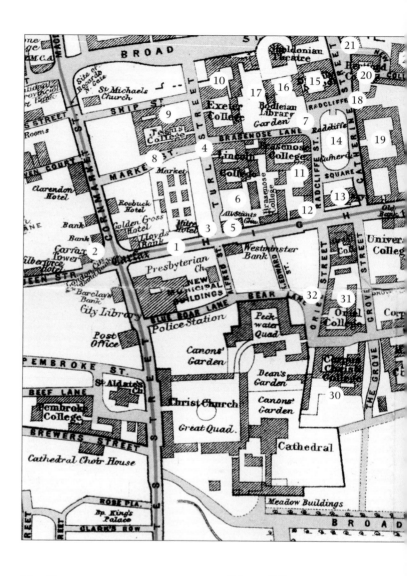

Map Key
1 High Street
2 Carfax Tower
3 Mitre Hotel
4 Turl Street
5 All Saints Church
6 Lincoln College
7 Brasenose Lane
8 Market Street

9 Jesus College
10 Exeter College
11 Brasenose College
12 St Mary's Entry
13 St Mary the Virgin
14 Radcliffe Camera
15 Bodleian Library
16 Divinity School
17 Convocation House

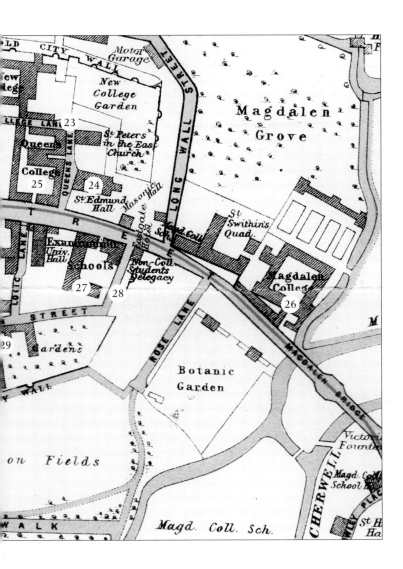

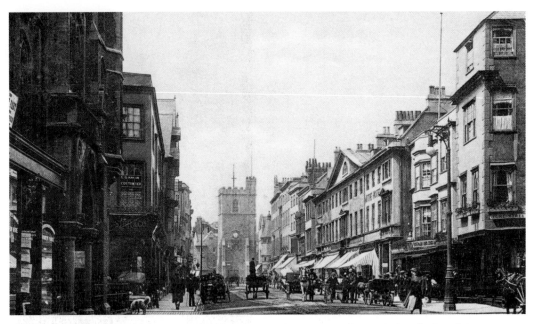

High Street at the junction of Turl Street with the Mitre Hotel on the immediate right-hand side and the Westminster Bank on the left-hand side of the picture, looking towards Carfax Tower. Much horse-drawn traffic can be seen using the street.

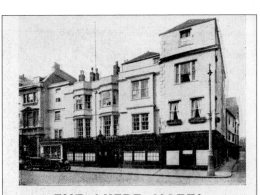

THE MITRE HOTEL,
OXFORD.

THIS well-known Hotel for Families and Gentlemen, which is situate in the centre of the finest street in Europe, close to the Colleges, and within an easy distance of the river, has been enlarged and much improved. While the traditional antiquity of the building has been carefully preserved, visitors will find in it all the refined comforts of a **Modern Hotel.** The " **Mitre** " is largely patronized by distinguished English, American, and Continental visitors, and is celebrated as one of the most economical first-class Hotels in the United Kingdom.

DINING, DRAWING, READING, AND SMOKING ROOM, LOUNGE, GOOD SUITES OF ROOMS, and five SPACIOUS BILLIARD ROOMS.
ELECTRIC LIGHT.
A Night Porter in attendance.

TARIFF ON APPLICATION TO—
C. J. VERT, Secretary,

Telephone: 335. Telegrams: " Mitre," Oxford.

A stylish advert for the Mitre Hotel on the High Street from the 1920s.

The Mitre Hotel courtyard in the 1930s.

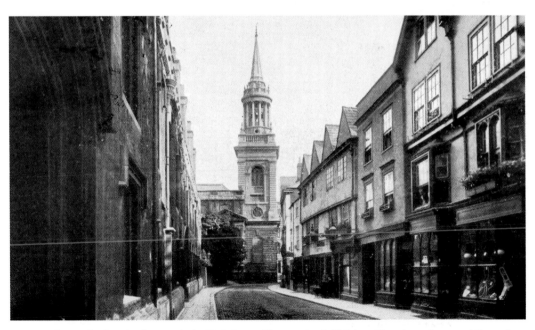

Turl Street looking back towards the High Street. The steeple of All Saints Church can be seen at the end of the street and Lincoln College is on the left-hand side of the picture. Turl Street takes its name from the 'twirl' gate or turnstile that was at the city wall at the Broad Street end of Turl Street.

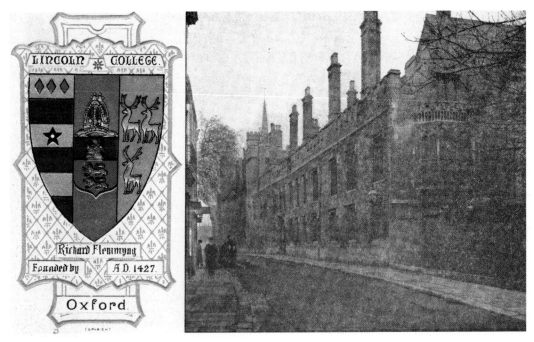

Lincoln College was founded by the Bishop of Lincoln in 1427 to train theology students. Owing to the college not being endowed with large sums of money, the college buildings are little altered over the centuries. They still have an old-world charm about them today.

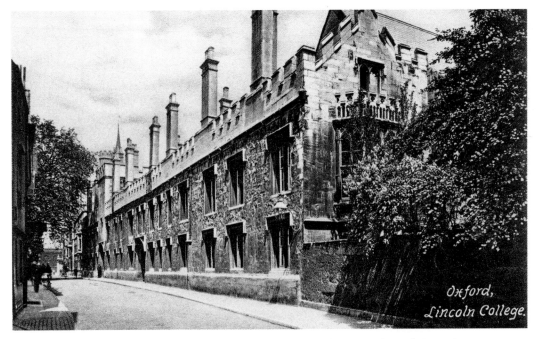

Lincoln College library is housed in All Saints Church at the end of Turl Street on the High Street. One notable college member was the Rector Tatham, who once gave a sermon that was so boring and long that the only person to stay for the duration was found at the end to be dead.

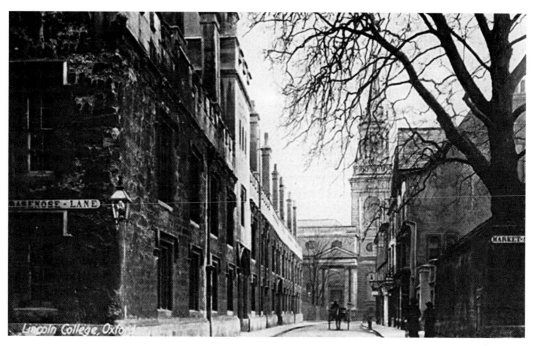

Looking down Turl Street from the junction of Brasenose Street and Market Street. Lincoln College is on the left-hand side of the picture and All Saints Church can be seen at the end of Turl Street.

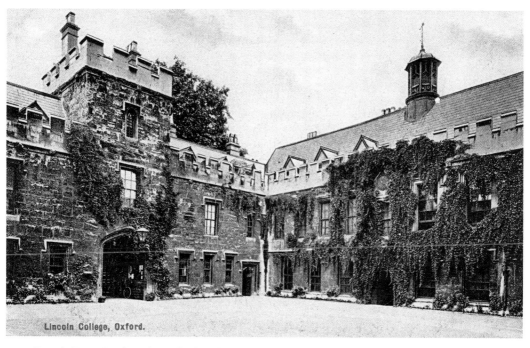

Lincoln Front Quadrangle was built in the 1430s and is little changed from the original builders' work. It is a fine example of buildings from the Middle Ages. John Wesley, the Methodist reformer, was a Fellow at the college.

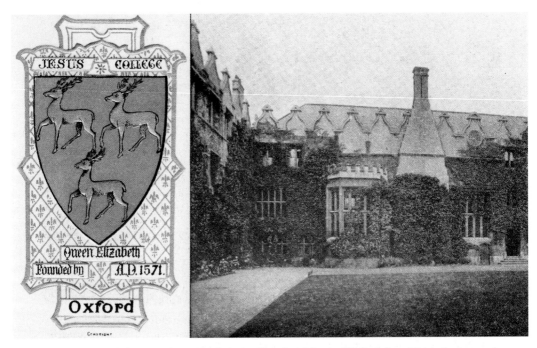

Jesus College was founded in 1571 by Dr Hugh Aprice (Price) and Queen Elizabeth I, and its students were mostly from Wales until the end of the nineteenth century. Price provided some of the funding for the construction of the college but only saw part of the college buildings completed as he died in 1574.

On Hugh Aprice's death the college was to be paid an endowment of £60 per year, but sadly for the college it was found that properties in Brecon that he owned were mortgaged and not owned outright by him. His estate only yielded a sum of £600.

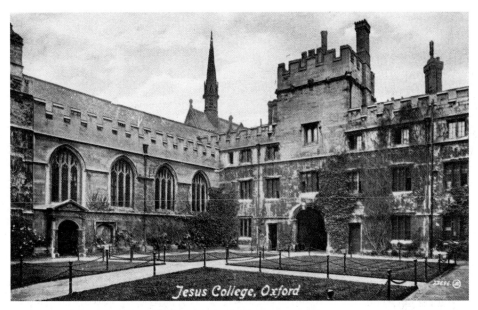

Jesus College, Oxford

The First Quadrangle is very pretty but relatively small, and the range in the picture is Elizabethan and Jacobean in origin. One of Jesus College's most famous students was T. E. Lawrence , 'Lawrence of Arabia', who was awarded a first-class degree in history in 1907 and was a self-taught archaeologist from his boyhood.

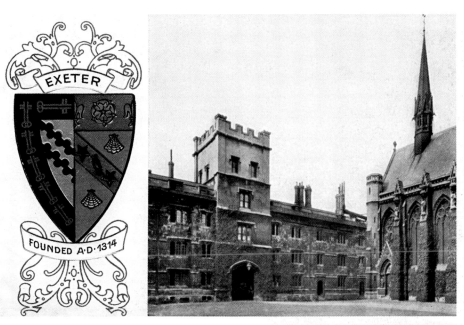

Exeter College was founded by Walter de Stapeldon, who was Bishop of Exeter in 1314. During its first 100 years it was known as Stapeldon Hall and had just over a dozen students who were being taught to be clergymen. The college expanded in the fifteenth century and the college motto is *Floreat Exon* which means 'Let Exeter Flourish'. The fictional Inspector Morse died in the Front Quadrangle shown in the picture above.

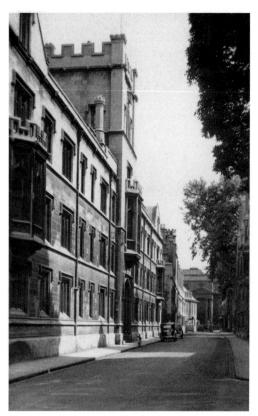

Exeter College on Turl Street. The gatehouse tower is the oldest part of the college, dating from 1432. One of its former students was Philip Pullman, author of the trilogy *His Dark Materials*. Exeter College is the trilogy's basis for Jordan College, home to Lyra, the story's heroine.

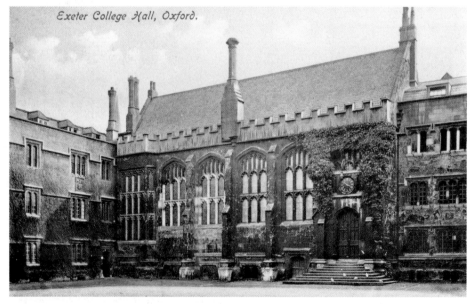

Exeter College dining hall in the Front Quadrangle. Exeter's most famous student was the author J.R.R. Tolkien, who attended the college between 1911 and 1915. He later wrote *The Hobbit* and most of *The Lord of the Rings* while working at Pembroke College, Oxford.

Exeter College Chapel, designed by Sir George Gilbert Scott and built between 1854–60 at a cost of £17,000. It takes its shape from the Sainte Chapelle in Paris. There is stained glass in most of the windows, mainly by Clayton & Bell, and they look stunning on a sunny day.

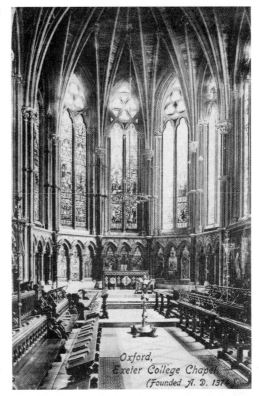

Oxford,
Exeter College Chapel
(Founded A. D. 137...)

Below: The Fellows Garden at Exeter College is said to be one of prettiest in Oxford, and has an air of peace and tranquillity after the hurly-burly of Turl Street only a few metres away. The building on the left-hand side of the picture is the college library, designed by Scott and built between 1856–57, and the low tower on the right of the picture is part of the Bodleian Library.

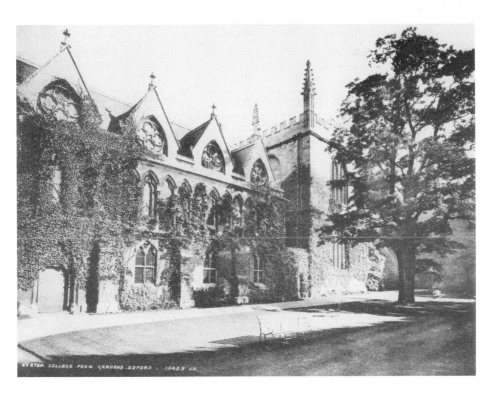

EXETER COLLEGE FROM GARDENS OXFORD . 15429 J.V.

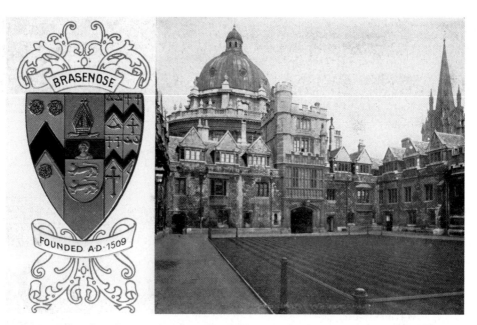

Brasenose College dates from 1509 and was founded by Sir Richard Sutton, a lawyer, and William Smith, Bishop of Lincoln. The college takes its name from an earlier building on the site, Brasenose Hall, and its door-knocker.

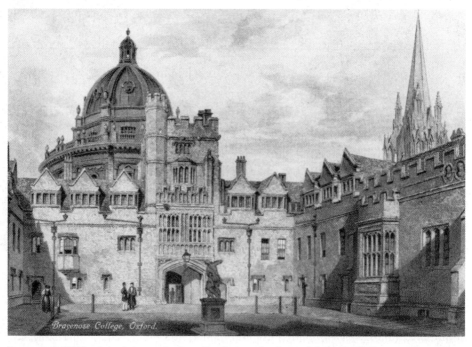

Brasenose's Old Quadrangle is overshadowed by the massive dome of the Radcliffe Camera. The college name is very unusual and is believed to come from the door-knocker which looked like a snout made of brass, hence 'Brazen Nose' or 'Brasenose', but it could also come from the corruption of 'brasenhuls', which means brewery.

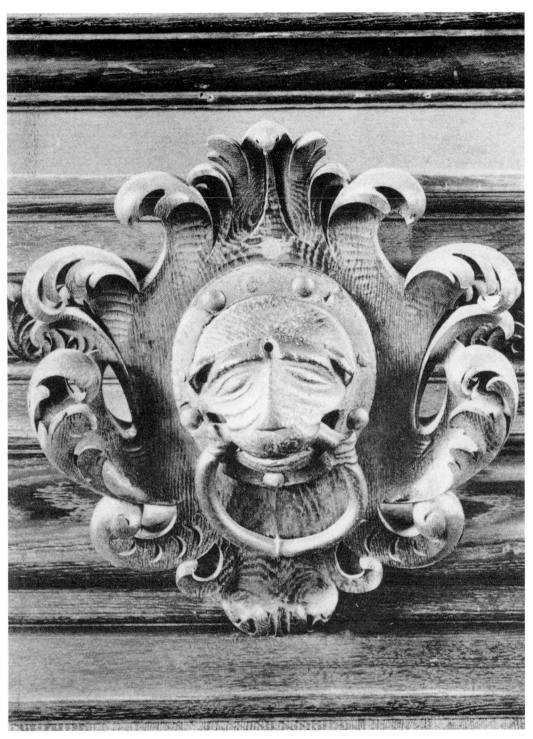

The door knocker was stolen from Brasenose Hall in 1333 and taken by rebellious students to Stamford, Lincolnshire. The college got the knocker back in the 1890s but they had to purchase the whole building to retrieve it. To stop it being stolen again, it is now safely kept in the college dining hall.

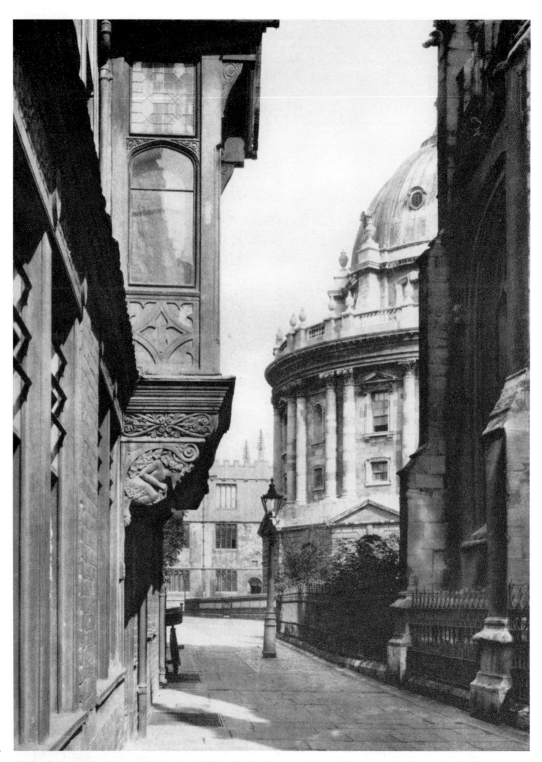

St Mary's Entry runs between Brasenose College and St Mary the Virgin Church and leads onto Radcliffe Square.

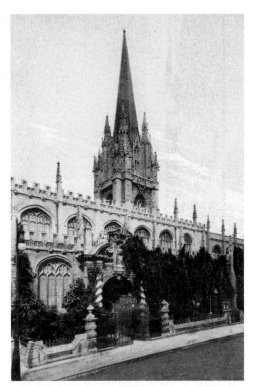

St Mary the Virgin Church was started in 1315 on the site of St Mary's Church. For a time it was the centre of university life, being home to the library, treasury, and used for both lectures and university ceremonies. The spire was restored in 1861 by J.C. Buckler.

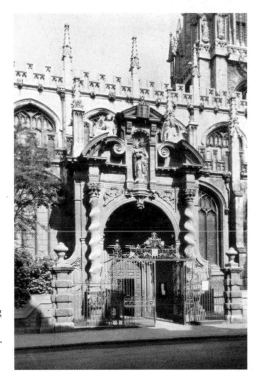

The porch erected in 1637 is in an Italian style with twisted columns and the figure of the Virgin holding the Holy Child in her arms. The porch was damaged by Puritans but restored by Sir Gilbert Scott in 1865. It is best viewed in the evening when the setting sun illuminates it.

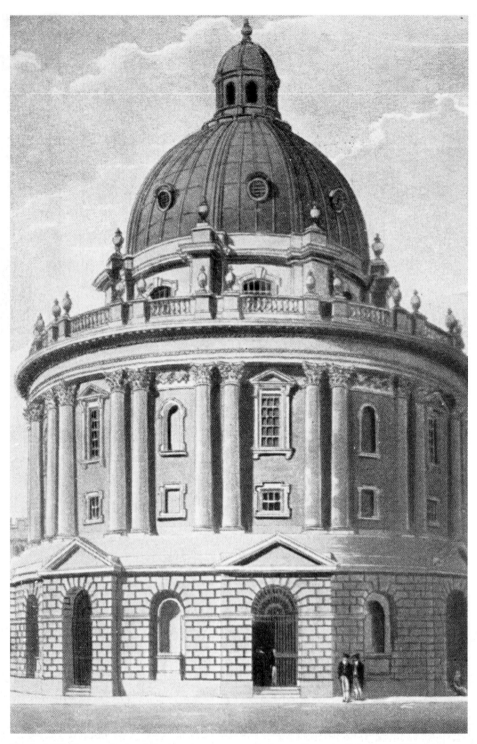

The Radcliffe Camera. In Greek, 'camera' means a vaulted room. It was built by James Gibbs between 1737–49 to provide a home for the Radcliffe Science Library. John Radcliffe funded the building with a bequest of £40,000. He died in 1714.

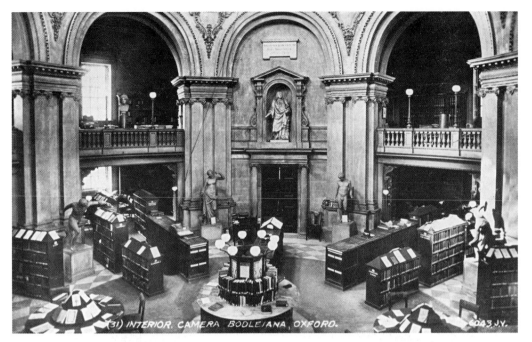

The interior of the Radcliffe Camera, now part of the Bodleian Library. When the Radcliffe Science Library moved to another building, it became the reading room for the Bodleian Library and it has the History and English collections. But it is a bit like the tip of an iceberg, as beneath Radcliffe Square there is space for 600,000 books.

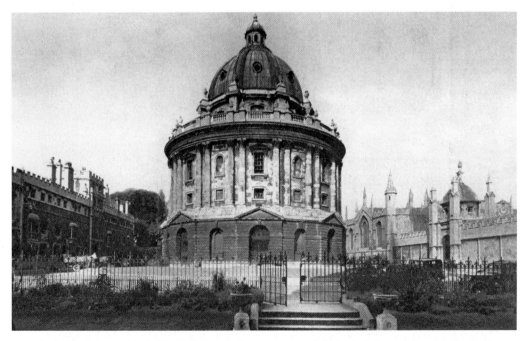

Radcliffe Square, with the Radcliffe Camera in the centre and All Souls College on the right-hand side and Lincoln College on the left-hand side.

BNC?!

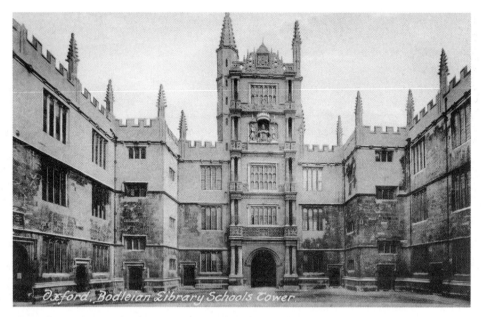

The Bodleian Library Schools Quadrangle. Construction was started in 1613, the day after the funeral of Sir Thomas Bodley, who is credited as the founder of the Bodleian Library. The first library of Oxford University dates from 1320, located in the rooms above the Old Congregation House.

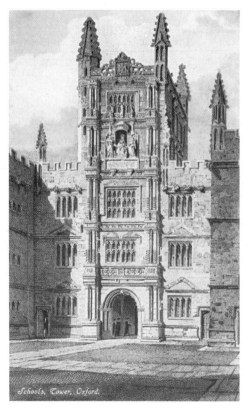

The Schools Tower in the Schools Quadrangle of the Bodleian Library. The gateway at the bottom of the tower leads onto Catte Street. The purpose of the quadrangle was to house lecture and examination rooms, hence the name Schools Quadrangle.

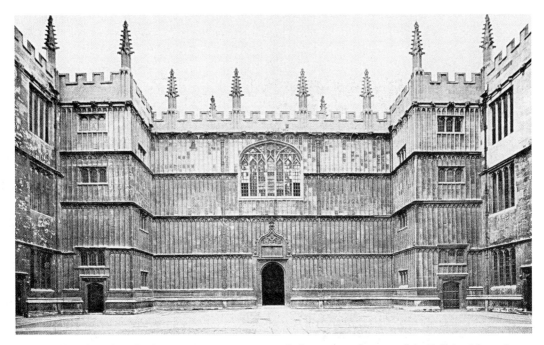

Looking from the Schools Tower gateway, west towards the entrance doorway of the Bodleian Library in the centre of the picture is the Arts End of the building. Behind this building is the Divinity School on the ground floor and Duke Humfrey's Library on the first floor.

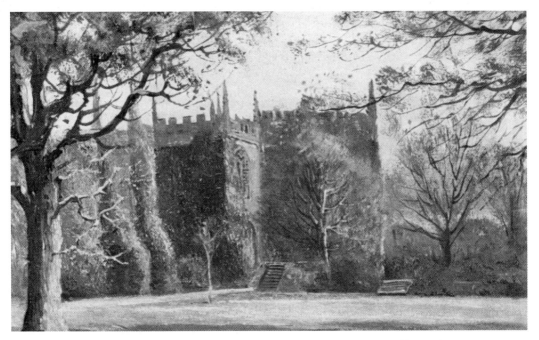

The Divinity School, seen from Exeter College Fellows' Garden, is a fine example of late Gothic architecture. Started in 1424 but not completed until 1478. A number of master masons worked on the building, and a lack of funding saw changes in design over the fifty-four years of construction.

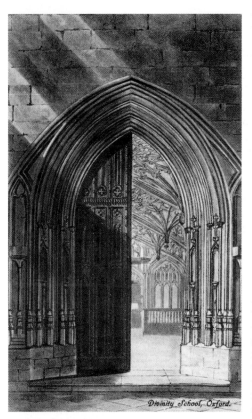

The doorway into the Divinity School, built by master mason Richard Winchcombe, who started work on the building in 1430 and also built most of the outer shell of the building.

Divinity School, Oxford.

Opposite below: The Duke Humfrey's Library was built on top of the Divinity School and was added on to the existing building, work starting in the early 1450s. It takes its name from Humfrey, Duke of Gloucester, who gave the books to the University. Many of the books were chained to the bookcases to stop their removal. Most of these books were burnt or sold during the Reformation.

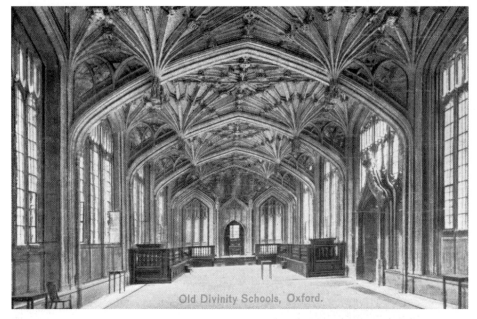

Old Divinity Schools, Oxford.

The crowning glory of the Divinity School is its vaulted ceiling, but this was not started till 1478 and was completed in 1488, the work being overseen by an Oxford master mason, William Orchard.

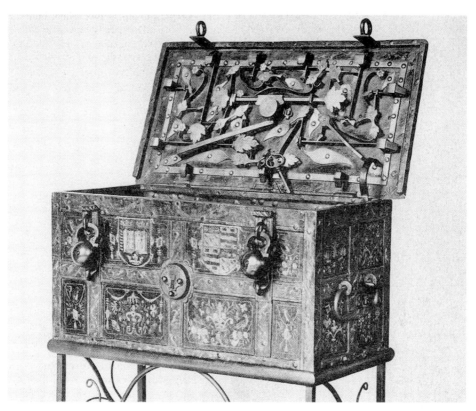

Standing in the Divinity School is the 'Blacke Iron Chest' of Sir Thomas Bodley, which was given to the Bodleian Library in 1622.

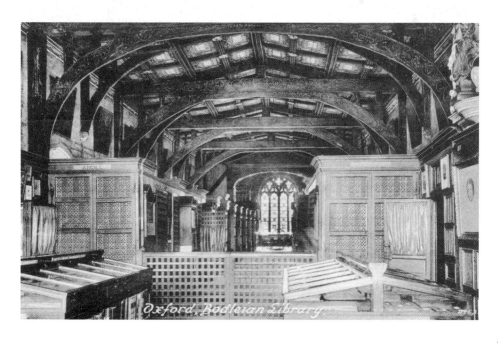

Oxford, Bodleian Library

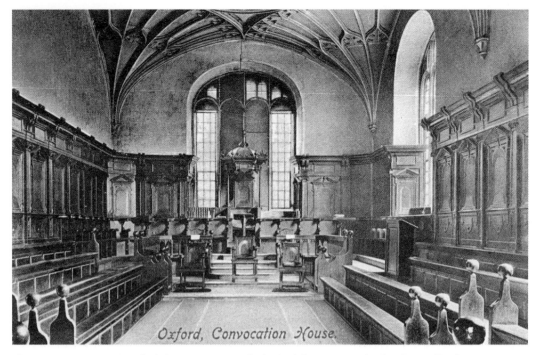

The Convocation House was built from 1634–37 at the back of the Divinity School and is used by the University legislative body of Masters of Arts. The Vice-Chancellor's throne can be seen at the end of the room.

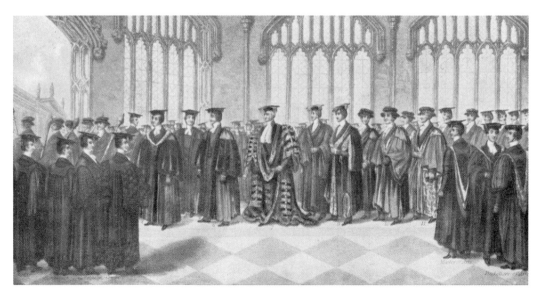

The costumes of the members of the University of Oxford. Going from left to right there are Verger, Yeoman Beadles, Esquire Beadles, Proctors, Doctor of Divinity, Doctor in Dress Gown, Chancellor of the University, Nobleman undress Gown, Nobleman Dress Gown, Doctor of Laws, Doctor of Music and Doctor of Medicine.

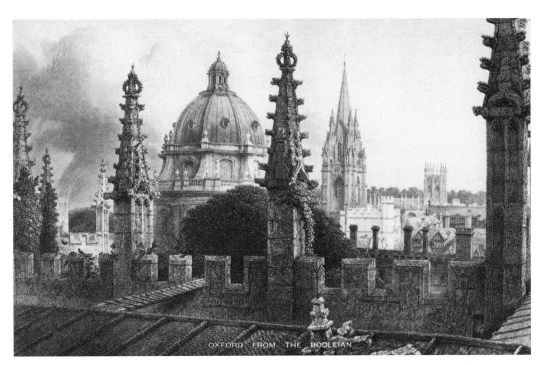

The view from the Bodleian Library roof looking towards the Radcliffe Camera, St Mary the Virgin Church and Merton College Chapel.

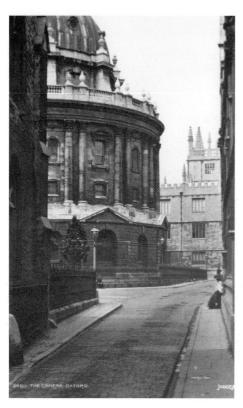

Looking down Catte Street from the High Street end, on the left-hand side is St Mary the Virgin Church and on the right is All Souls College. Further down the street can be seen the Radcliffe Camera and the Bodleian Library.

Opposite below: All Souls College's North Quadrangle was designed by Hawksmoor and was completed in 1733, with twin towers of Gothic design as the centre-piece to the quadrangle. The sundial on the left of the picture is believed to have been designed by Sir Christopher Wren.

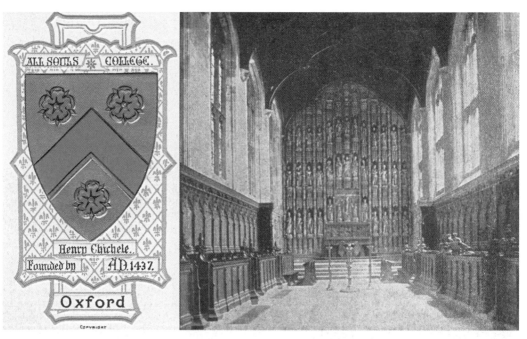

All Souls College was founded in 1438 by Archbishop Chichele of Canterbury, with Henry VI as a co-founder, in memory to all those who had died in the Hundred Years' War.

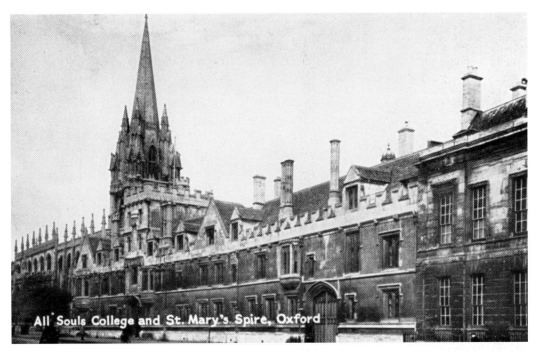

All Souls College frontage onto the High Street. This is one arm of the Front Quadrangle built between 1438–43. The front of the building was refaced in the late 1820s. Towering over the college is the spire of St Mary the Virgin.

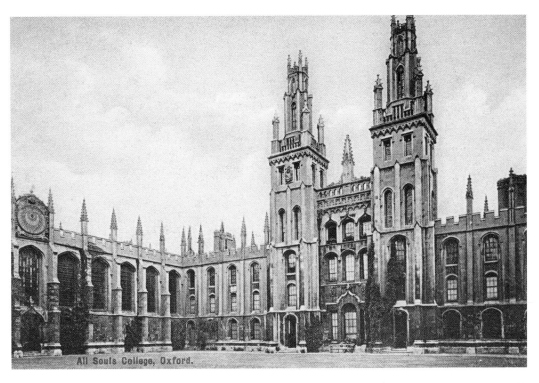

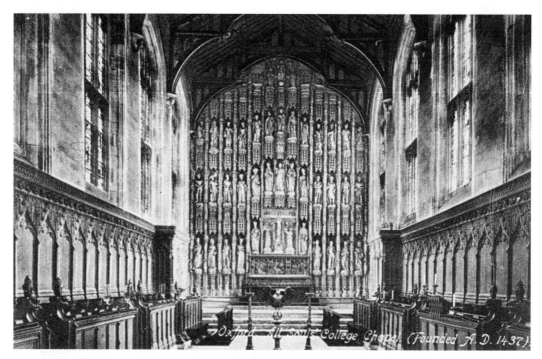

All Souls chapel has a very fine reredos behind the altar which would have been originally painted to make it more life-like, and it is said that there are still traces of the Medieval paint to seen on it. It was modelled on the reredos in New College Chapel, where Archbishop Chichele was a member.

Opposite below: Hertford College in a way can claim to be one of the oldest in Oxford. In the 1280s Elias de Hertford set up a residential hall for students, known as Hart Hall on the current site, but this was not a fully fledged college. The college came into being in 1874 and was funded by Sir Thomas Baring, a wealthy banker.

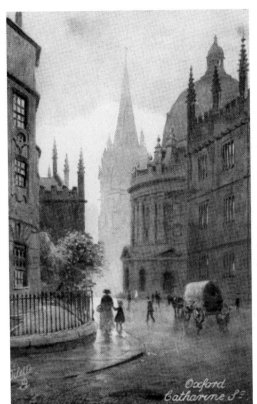

Looking up Catte Street from the junction of New College Lane. Hertford College and All Souls College are on the left-hand side and the Bodleian Library, Radcliffe Camera and St Mary the Virgin are on the right-hand side. The lane has had many name changes over the centuries, Cattestreete in the thirteenth century, Mousecatcher in the fifteenth century, Cat Street in the eighteenth century, Catherine Street in the nineteenth century and finally Catte Street in the 1930s.

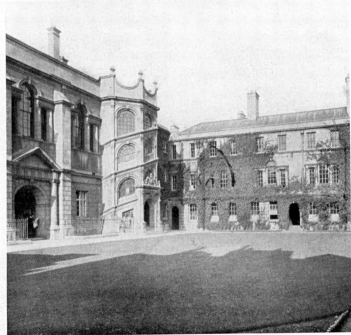

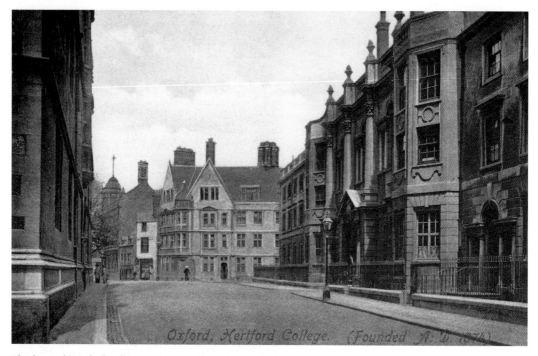

The front of Hertford College on Catte Street facing the Bodleian Library. The medieval frontage on Catte Street collapsed with a loud crash in the nineteenth century. At the end of the street, framed by the end of a building, can be seen a small lighter coloured building. This is the Octagonal House or Chapel.

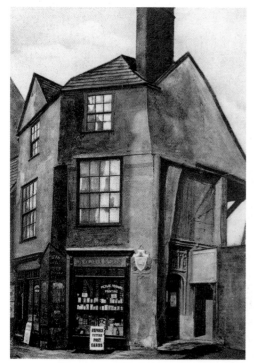

The Octagonal House or Chapel in the early part of the twentieth century, when it was occupied by Holywell Press, who were printers and publishers. There was a chapel on the site in the fourteenth century known as St Mary at Smith Gate, and by the 1580s it had become a private dwelling. In 1708 it became a shop and carried on, mainly as a shop, until 1923.

The Octagonal House was purchased by Hertford College in 1902 and became part of the college in 1923. It underwent major redevelopment in 1931 and became the Junior Common Room of Hertford College, as shown in the modern photograph here.

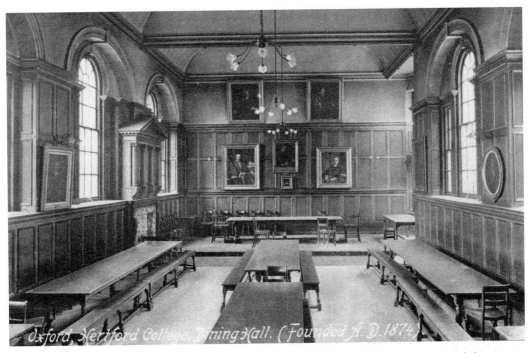

Oxford, Hertford College, Dining Hall. (Founded A.D. 1874)

Hertford College Dining Hall has the high table set into a bay at the end of the hall and strangely has two levels of windows on either side of it. It is the work of Sir Thomas Jackson.

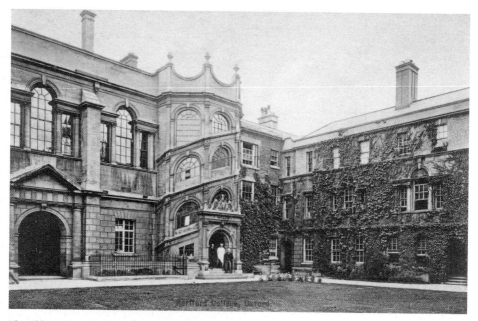

The Old Building Quadrangle at Hertford College. The college building is mostly the work of
Sir Thomas Jackson, who mixed different styles in his buildings. Just off centre of the picture is
Jackson's wonderful staircase where the windows follow the line of the stairs.

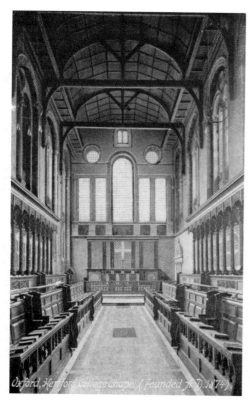

Hertford College Chapel, designed by
Sir Thomas Jackson and built in 1908,
looking towards the altar end of the chapel,
which is six bays in length. The east window
shown above has five lights, with the central
light being arched and of a Venetian style, and
is a fine sight at night when the chapel is lit
from New College Lane.

Opposite below: Looking back towards the
Bridge of Sighs on New College Lane from just
outside. On the right-hand side of the picture is
the home of Edward Halley, who was a Savilian
Professor of Geometry from 1703–42 and had
his observatory there. He is famous for his work
on the orbits of comets and calculated that the
comet of 1682, now known as Halley's Comet,
would return in 1758, as it did, but by then he
had been dead for fifteen years.

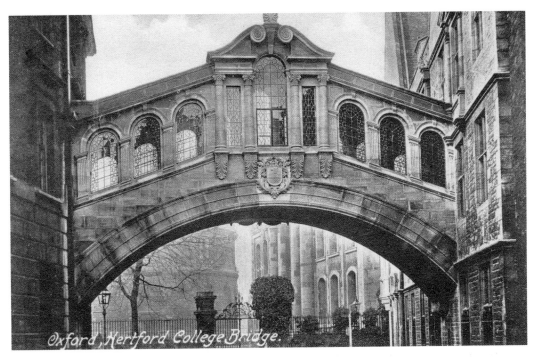

Oxford, Hertford College Bridge.

The Bridge of Sighs links the two halves of Hertford College across New College Lane, designed by Sir Thomas Jackson and built between 1813–14. The bridge has a very ornate central decorated bracket with columns and a scrolled pediment at the top.

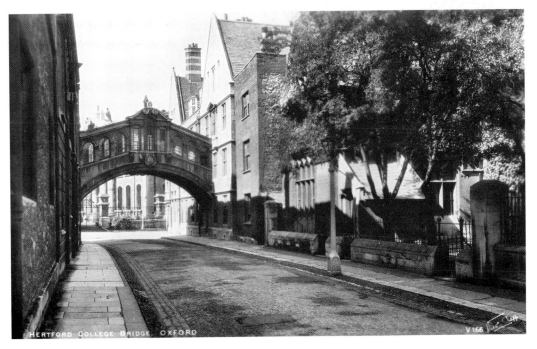

HERTFORD COLLEGE BRIDGE, OXFORD

V 166

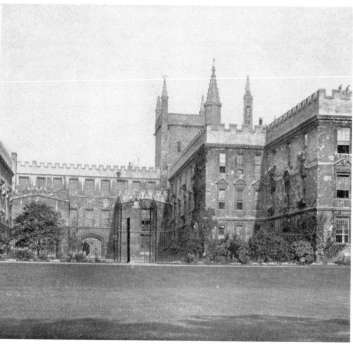

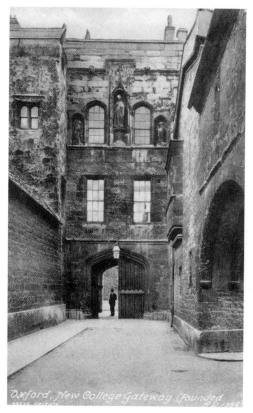

Above: New College stands at the end of New College Lane and was founded in 1379 by William of Wykeham, Bishop of Winchester and Chancellor of England. It was originally called the St Mary College of Winchester in Oxford.

The approach to the college is almost canyon-like with the high walls of the Cloisters on the left-hand side and the Warden's Barn on the right-hand side. Queen's Lane enters New College Lane via the arch on the right-hand side.

Monkey Tricks is a cartoon showing the students, all male at the time, using monkey skills to get back into the college after curfew.

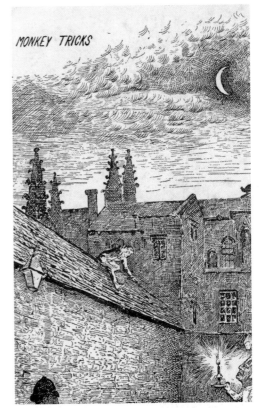

Below: New College Front Quadrangle is reached via the front gate just to the left of centre of the picture, with the Wardens Lodge above it. On the right is the college chapel with its Gothic stained-glass windows.

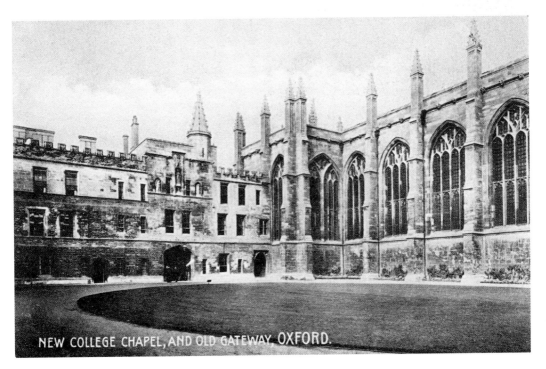

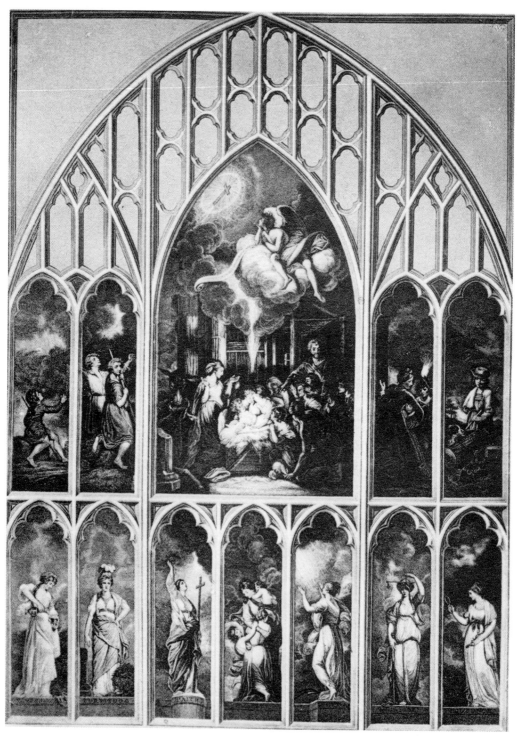

In the Ante-Chapel there are medieval stained-glass windows and the great west window, designed by
Sir Joshua Reynolds and made by Thomas Jarvis between 1778–85, showing the Nativity and the Seven
Virtues. There is a self-portrait within the window of Sir Joshua Reynolds as a shepherd.

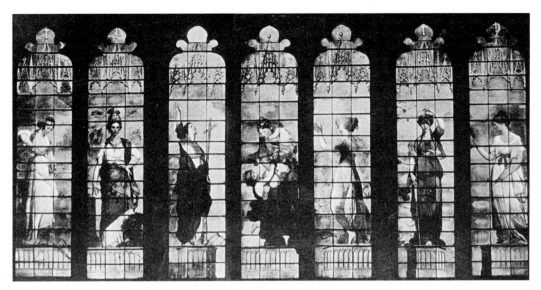

The lower section of the window shows the Seven Virtues. Going from left to right there is Temperance, Fortitude, Faith, Charity, Hope, Justice and Prudence. Many of this type of painted window were destroyed or replaced in the Gothic revival of the Victorian period.

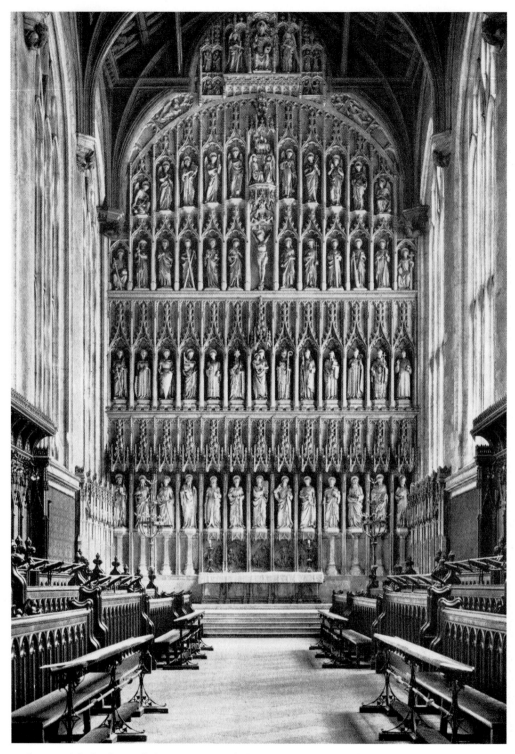

Looking towards the altar with the stunning reredos behind it. This is a nineteenth-century restoration, replacing a reredos made from stucco in 1789, and is made up of rows of figures.

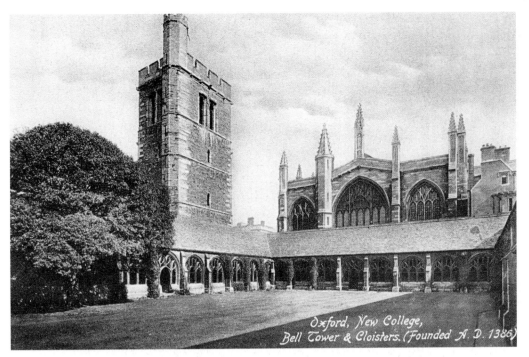

New College Cloister and Bell Tower. This part of the original college building was completed around 1400. The tree on the left-hand side of the picture is a very old Ilex (holly).

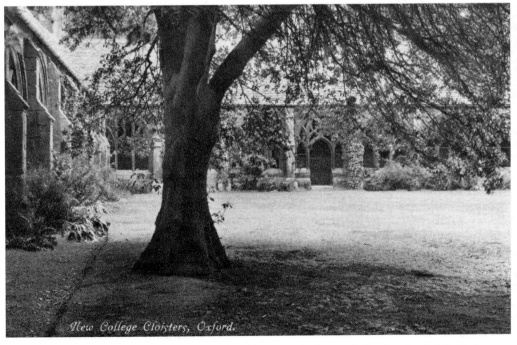

New College Cloisters looking from under the old Ilex Tree back towards the chapel end of the Cloister, a wonderful scene of peace and tranquillity.

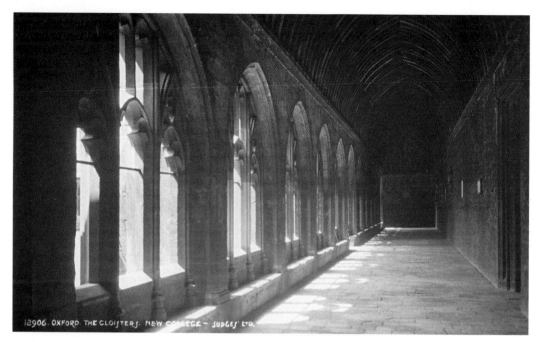

Inside New College Cloisters. There are graves under the flagstones and the walls have memorial tablets to former students and fellows of the college. It's nice to see a tablet commemorating Hugh Gaitskell, 1906–63, leader of the Labour Party in Opposition between 1955–63.

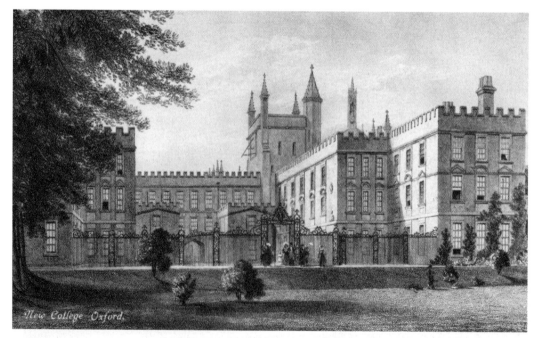

New College Garden Quadrangle, viewed from the college garden through the decorative wrought-iron screen, which is a copy of the eighteenth-century screen. The Garden Quadrangle is not a true quadrangle, being open on the east side to the garden.

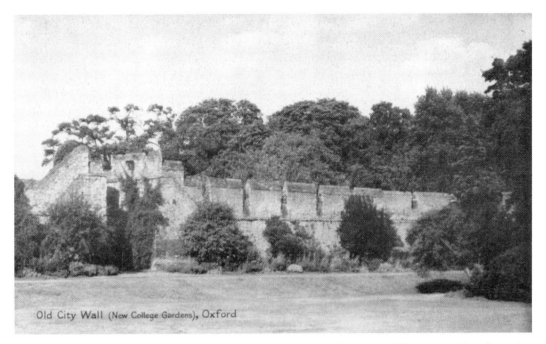

Old City Wall (New College Gardens), Oxford

The garden is enclosed on two sides by the old city wall, dating from the twelfth century. When the founder of the college obtained the land to build the college, he had to take responsibility for the repair of the wall.

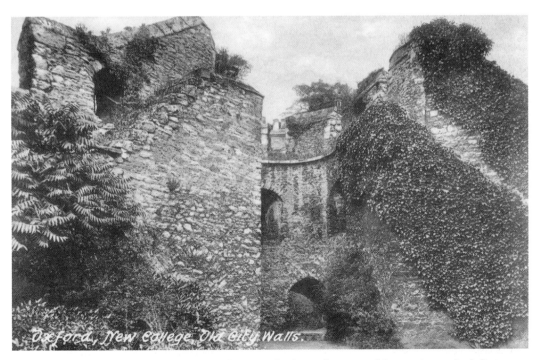

Oxford, New College Old City Walls.

The old city wall is inspected once every three years by the Lord Mayor and Corporation to check that it is in good condition.

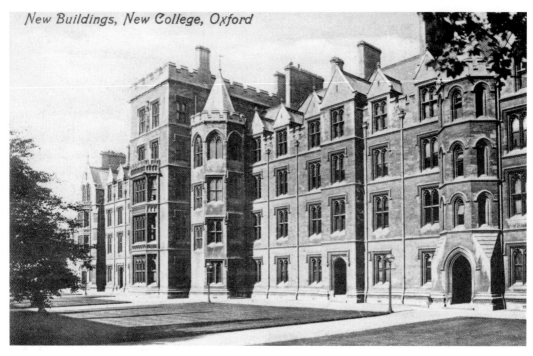

New Buildings, New College, Oxford

New Building, New College dates from the nineteenth century and looks towards the chapel and hall of the college. The back of the building fronts onto Holywell Street.

A fine view of All Souls College's North Quadrangle twin towers from Queen's Lane, with the dome of the Radcliffe Camera behind the towers.

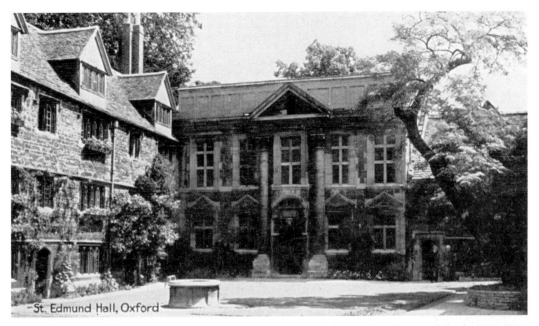

St Edmund Hall stands on Queen's Lane just before it joins the High Street. It is said to be the oldest place in Oxford for the education of undergraduates, dating back to the thirteenth century, but has only been an Oxford college since 1957.

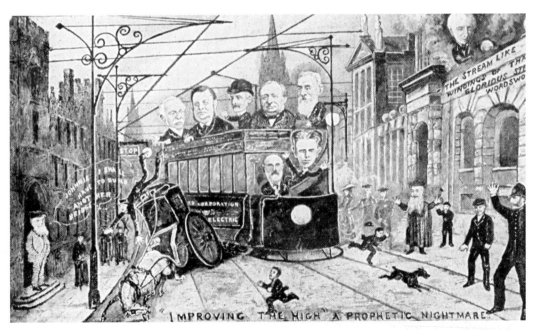

The High Street or High in 1905, when Oxford Corporation were going to take over the horse-drawn Tramways Company and introduce electric trams. Oxford University was not happy with the streets being festooned with electric cables and poles. The tram is full of members of Oxford Corporation and the white-bearded man on the left of the picture is Dr James Bright, who had widened Magdalen Bridge in 1899 for the horse-drawn trams. High costs eventually ruled out the scheme.

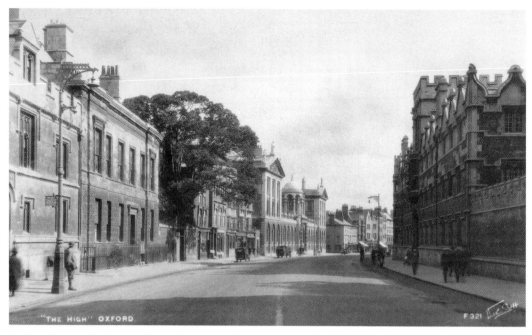

Looking down High Street or The High from just before University College. On the immediate right of the picture and further down on the left can be seen Queen's College, and not a tram or bus in view.

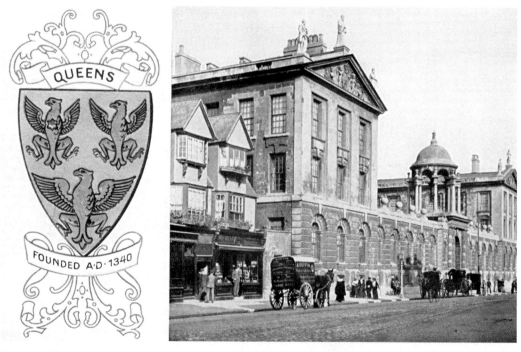

Queen's College was founded in 1341 by Robert de Eglesfield, who was a chaplain in the household of Queen Philippa and it was named after her; it was originally known as the Hall of the Queen's Scholars at Oxford. The picture above is the frontage onto the High Street.

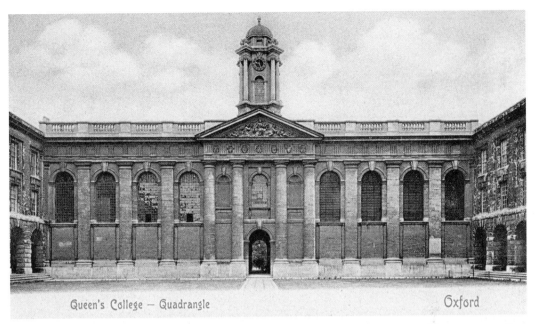

Queen's College — Quadrangle Oxford

Queen's College Front Quadrangle north range. It is unclear who designed this range but they were working to Wren's principles. The windows are separated by large Tuscan pilasters, with the centre of the building having Tuscan columns. The building is topped by an ornate cupola.

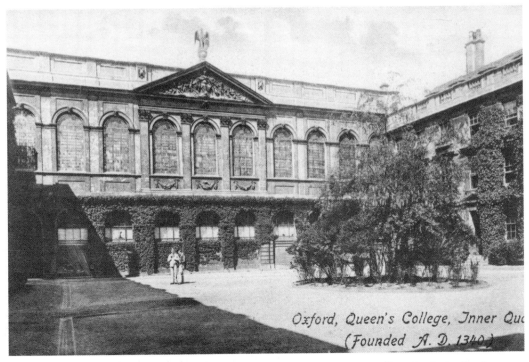

Oxford, Queen's College, Inner Qu
(Founded A. D. 1340)

Queen's College North Quadrangle. The college was founded mainly for men from Cumberland and Westmorland and had fellows, chaplains and 'poor boys'.

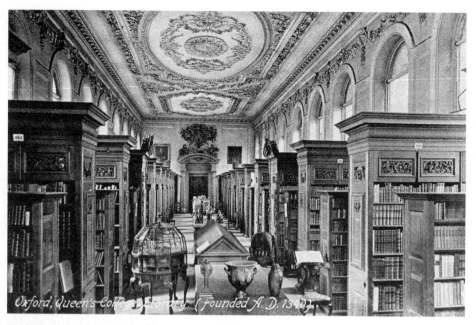

The library is on the west side of the Inner Quadrangle and was built between 1692–95, with the wonderful plaster ceiling being the work of James Hands. The library houses two major collections; one used for research on a wide range of subjects and built up over the last 300 years, and the second of rare and antique books.

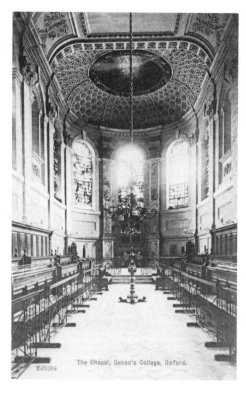

Queen's College chapel with its central apse ceiling, and a circular painting of the Ascension by Thornhill, dated 1716.

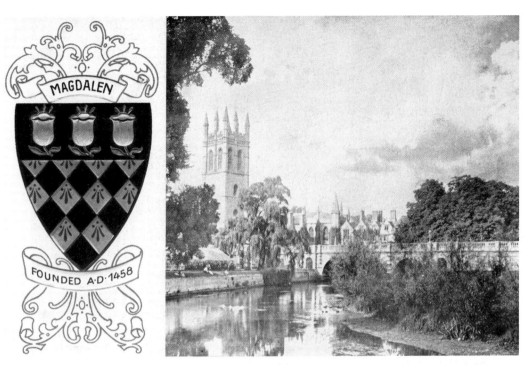

Magdalen College (pronounced Maudlin) was founded in 1458 by William Waynflete, who later became Bishop of Winchester and the Chancellor of England. Originally on the site was the Hospital of St John, but Waynflete had much of this demolished.

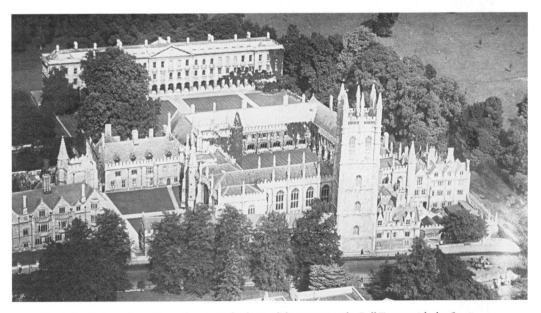

Magdalen College viewed from the air. In the front of the picture is the Bell Tower with the Great Quadrangle behind it and with St John's Quadrangle to the left. At the back of the picture is the New Building and the wooded area to the right of the college is part of Addison's Walk.

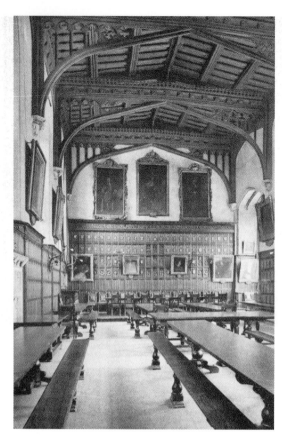

Magdalen College Dining Hall. Construction on it was started in 1474 and it was restored in 1902 by Bodley and Garner, and the roof is a copy of the original roof. Some of the panelling at the dais end of the hall is from the early Renaissance period.

Below: The Great Quadrangle at Magdalen College with the Founders Tower partly-covered in ivy on the right of the picture and the Great Tower, or Bell Tower, on the left. Construction on the Great Tower started in 1492 and was completed in 1509. The tower is 144ft tall and is the tallest medieval tower in Oxford. The quadrangle is cloistered on all sides giving a monastic, medieval feel to it.

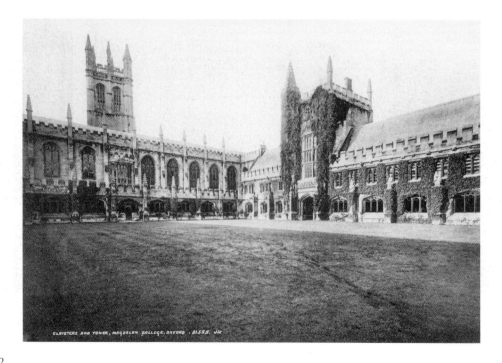

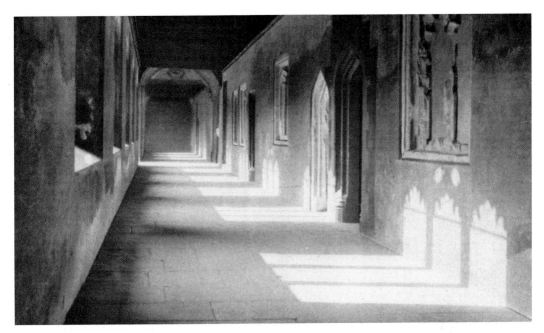

Magdalen College cloisters, with the sun streaming in through the three-light windows onto the quadrangle.

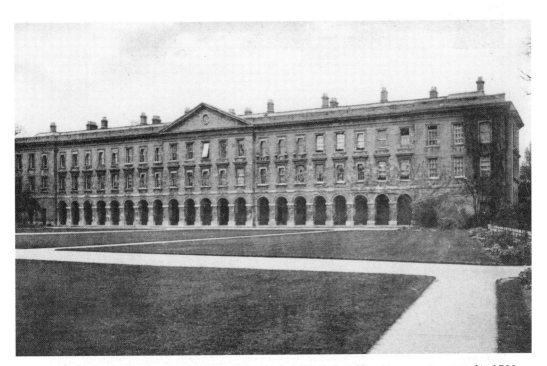

Behind the Great Quadrangle across a wide lawn stands the New Building. Construction started in 1733 and it was to be one side of a large quadrangle, but the other three sides were never built. The writer and lecturer C.S. Lewis had rooms in the building after the First World War.

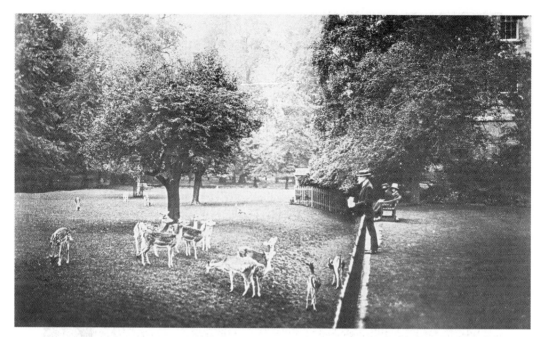

The Magdalen Grove Deer Park is situated at the back of the college; the deer herd is over 300 years old.

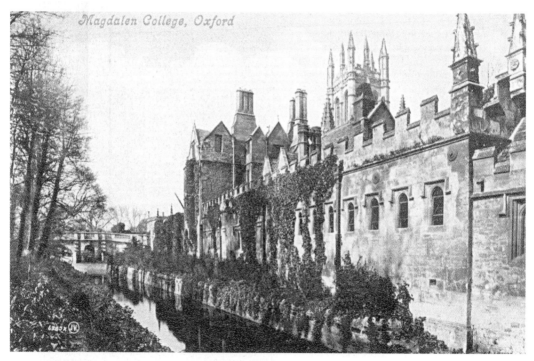

The Holywell mill stream runs beside the college buildings before rejoining the River Cherwell at Magdalen Bridge, with Addison's walk being on the opposite bank from the college.

Above: In the corner of St John's Quadrangle can be found the open-air pulpit, and on St John the Baptist's Day a sermon would be given from it. The ground would be covered in straw and rushes and the buildings around covered in green boughs. This was to celebrate the preaching of the Baptist in the wilderness.

The outdoor pulpit perched on the side of St John's Quadrangle. St John the Baptist's day is the 24 June, but the sermon is given on the closest Sunday. The preaching of the sermon stopped in 1766, but was revived in 1896 by Cosmo Lang, who later became the Archbishop of Canterbury.

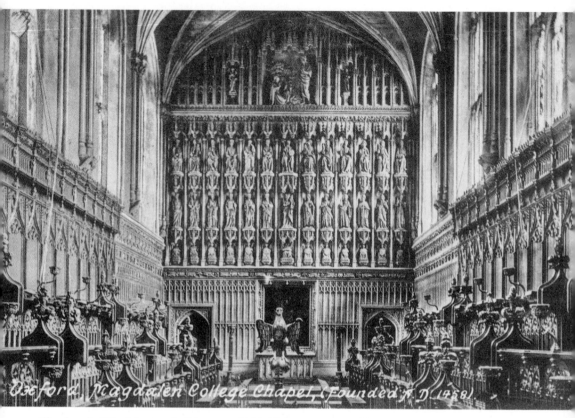

Oxford. Magdalen College Chapel (Founded A.D. 1458)

The chapel at Magdalen was built between 1474–80, but was restored by L.N. Cottingham between 1829–34. However, the reredos, seen behind the altar on the picture above, dates from the 1860s and is the work of Earp.

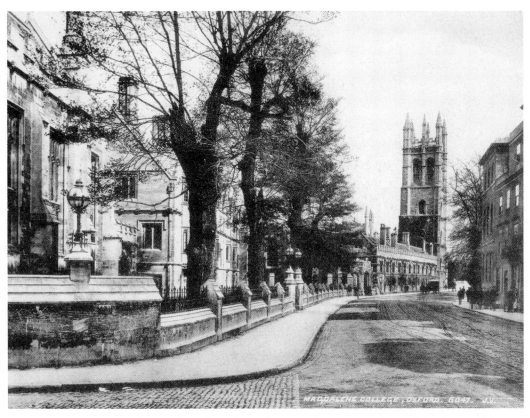

Looking down the High Street from the junction of Long Wall Street towards Magdalen Tower. All the frontage on the left of the picture is part of the college.

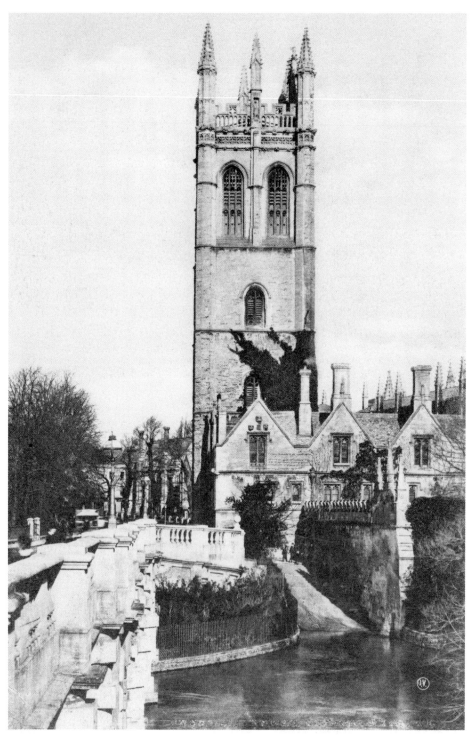

Magdalen College Tower is the major landmark that can be seen as you cross Magdalen Bridge when entering the City of Oxford from the south. What a powerful signal of the college's wealth it must have given in the medieval period, as it still does today.

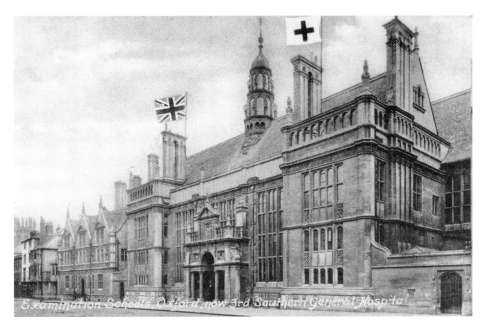

The Examination Schools stand on the High Street and were completed in 1882, designed by Sir Thomas Jackson and are thought by some to be his masterpiece. The building became the Third Southern Military Hospital during the First World War and was also used as a hospital during the Second World War. The postcard above is from the 1914–18 period, but the flags have been added to a slightly earlier picture.

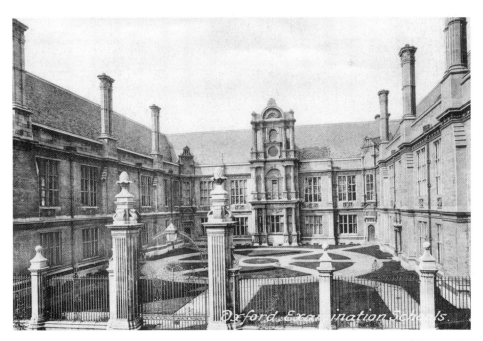

The Examination Schools viewed from Merton Street. The building stands on the site of the Angel Inn, which is believed to have been the first inn in England. The building is used for both lectures and examinations, and the dress for examinations is sub-fusc clothing (black and white).

Merton Street comes off the High Street immediately after the East Gate Hotel and turns sharply to the right just after the Examinations Schools and runs past Merton College. It is still has a cobbled road surface, as can be seen in the picture here.

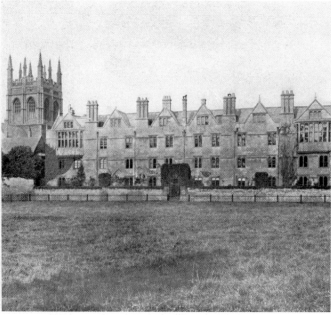

Merton College was founded in 1264 by Walter de Merton, who was for a period of time Chancellor of England and Bishop of Rochester. It originally had twenty fellows, with undergraduates first attending the college in the 1380s.

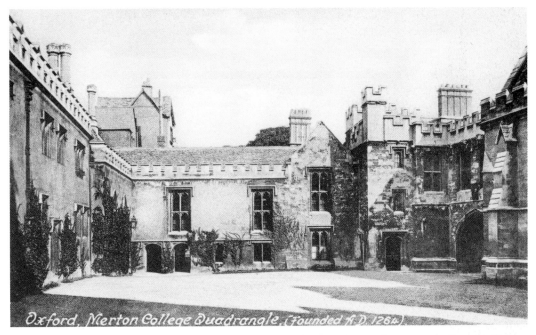

Merton College Front Quadrangle, much of which dates from the thirteenth century. On the right of the picture is the end of the college hall with the dark, arched opening leading into the Fellows Quadrangle.

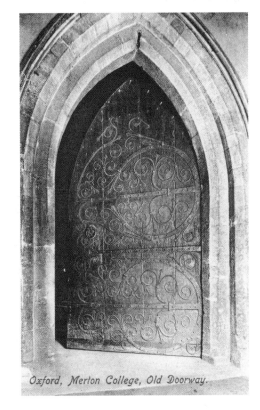

Merton College's hall doorway dates from the thirteenth century with its wonderful decorative scrolled-ironwork, which is also very practical as it makes the wooden door much stronger against attack by axes.

Oxford, Merton College, Old Doorway.

101

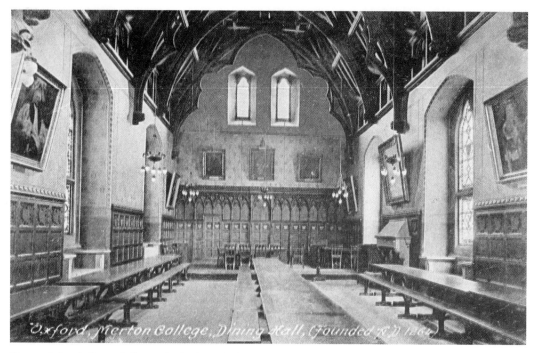

Merton College's dining hall was also built in the thirteenth century but was rebuilt between 1872–74 by Scott. The roof is very steep and has fine timberwork. It is believed to be an accurate copy of the original thirteenth-century roof.

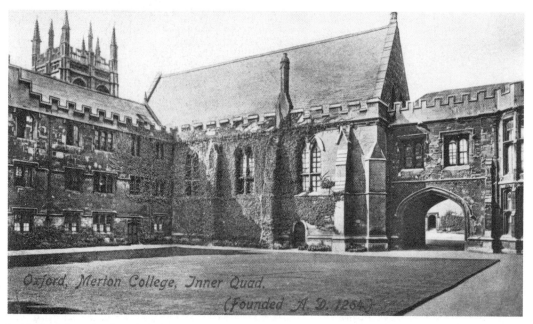

Inside the Fellows Quadrangle looking towards the dining hall, where it is believed that the author Tolkien and his wife Edith celebrated their fiftieth wedding anniversary in 1966. Tolkien was the Merton Professor of English Language and Literature from 1945 until 1959, when he retired.

New Quadrangle and Gardens, Merton College, Oxford.

Merton College looking into St Alban's Quadrangle from the garden. It is named after St Alban's Hall, an academic hall taken over by the college in the nineteenth century. It was built between 1904–10 in a Tudor style.

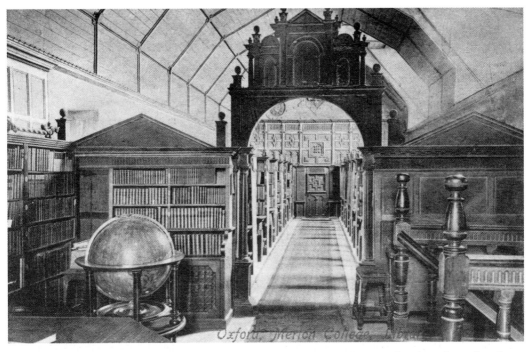

Merton College Library is said to date from the sixteenth century and is located in the Mob Quadrangle, which is dated to the fourteenth century and is the oldest quadrangle in Oxford.

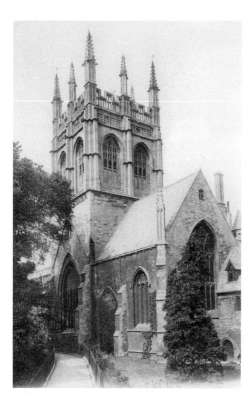

Merton College Chapel was started around 1290 and the roof was completed in 1297. The tower above the crossing was started in 1448. This is one of the largest college chapels in England, but Walter de Merton planned it to be much larger than what we see today.

Opposite below: In the Front Quadrangle stands the 1581 Charles Turnbull sundial, which is topped by a pelican, a symbol for the body of Christ (Corpus Christi). It was believed that the pelican would pluck blood from its breast to feed its young.

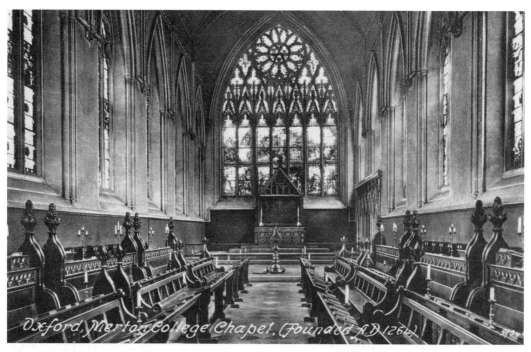

Merton College Chapel looking from the crossing point towards the altar. The stained glass window behind dates from the early period of the church's construction.

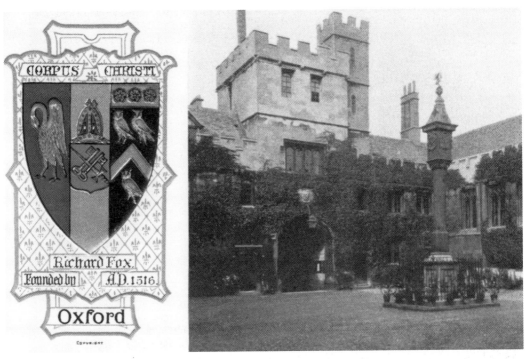

Corpus Christi College was founded in 1517 by Richard Fox, the Bishop of Winchester, and was for the teaching of Latin, Greek and Theology. The college is quite small and stands at the end of Merton Street.

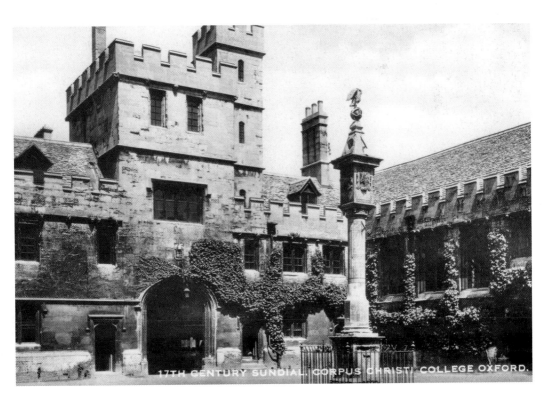

Oriel College was founded by the English King Edward II in 1326. He promised the Virgin Mary he would found an Oxford college in her name when escaping from the Battle of Bannockburn in Scotland in 1314, hence the three lions on the college coat of arms.

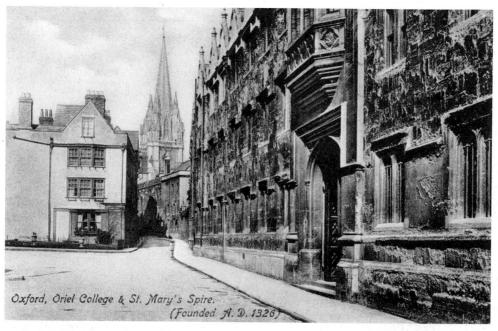

Oriel College frontage on Oriel Street/Oriel Square. This is one arm of the Front Quadrangle built in the seventeenth century. The college was originally called The House of the Blessed Mary the Virgin in Oxford, but later became known as Oriel College after a building on the site known as 'L'Oriole'.

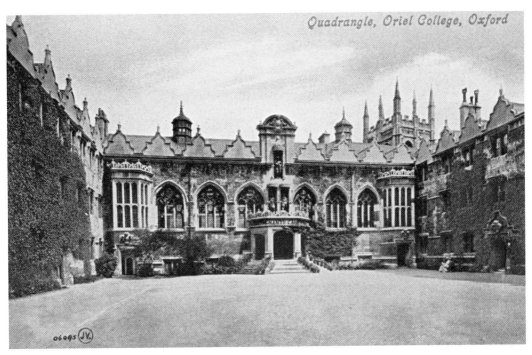

Oriel College Front Quadrangle, with the porch leading into the hall in the centre of the picture. Over the porch is the inscription *Regnante Carolo* which means 'When Charles Reigns'.

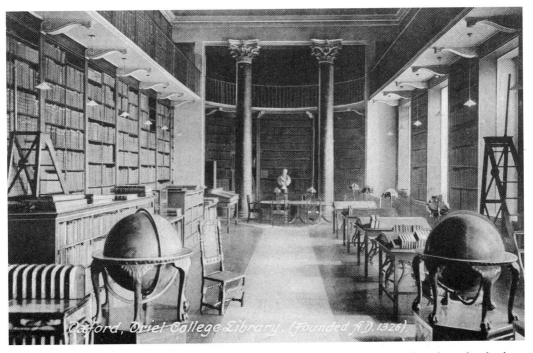

The first floor of Oriel College Library by James Wyatt, built in 1788, is quite simple in design but for the two large scagliola columns in front of the apse (semicircular extension at the end of room).

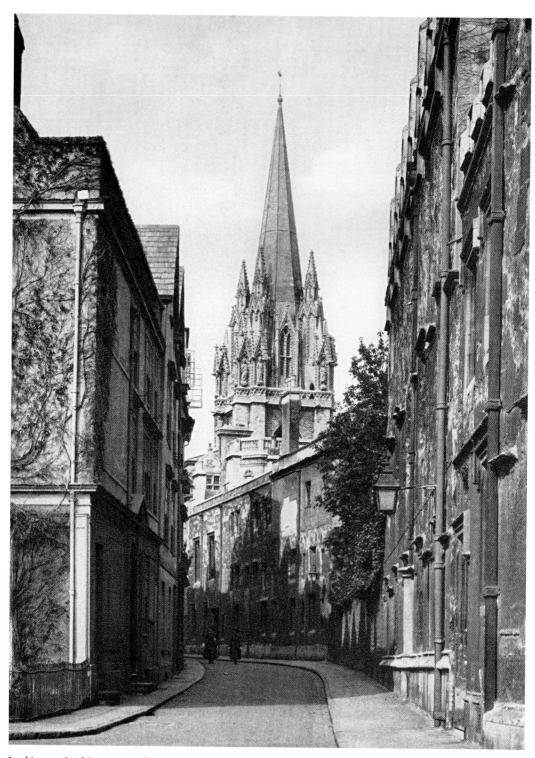

Looking up Oriel Street towards the High Street from the junction with Bear Lane. Oriel College is on the right-hand side of the picture and soaring towards the heavens is the spire of St Mary the Virgin Church.

Looking down Magpie Lane from the High Street. On the right of the picture is the Rhodes Building of Oriel College, and the lane goes down to Merton Street. In the thirteenth century it was known as Grope Lane because of its bad reputation. In the seventeenth century it was called Magpie Lane because of the sign of a magpie on a tavern. It became Grove Lane in the nineteenth century before reverting to Magpie Lane in the late 1920s.

Below: University College was founded by William of Durham, who had moved from Paris to Oxford in 1229 and on his death in 1249, had left 310 marks to the University. The college opened in 1280.

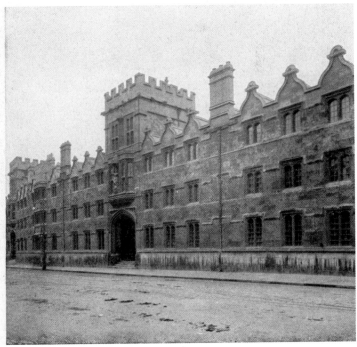

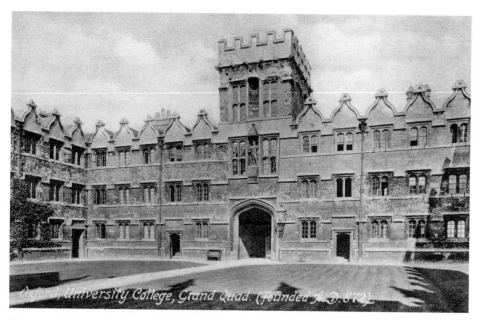

University College Front Quadrangle was started in 1634. One of the college's most famous students was the poet Percy Bysshe Shelley, who only lasted about six months as an undergraduate before being sent down (expelled) for bad behavior. Just up the High Street from the college is the site of a house where Robert Boyle lived from 1655–68. He discovered the gas law known as Boyle's Law.

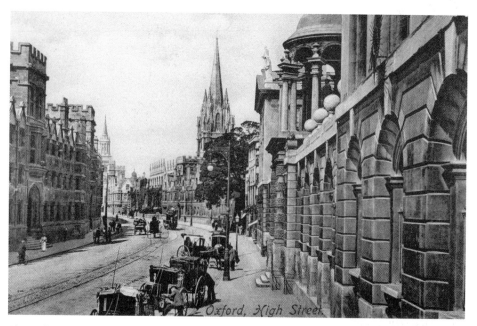

The High Street viewed from outside Queen's College. On the left is University College and further up the street can be seen the spires of St Mary the Virgin and All Saint's Church. A group of horse-drawn cabs is in the foreground of the picture which dates from the very early part of the twentieth century.

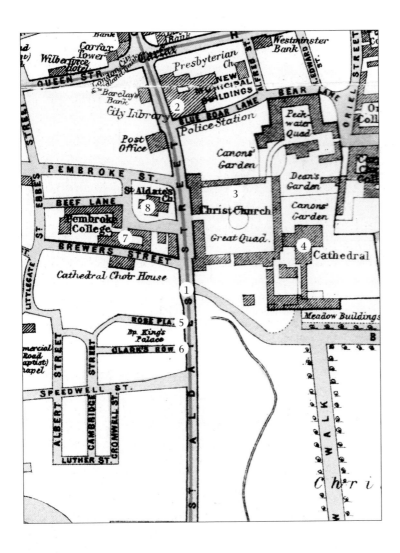

Map Key
1 St Aldate's Street
2 Oxford Town Hall
3 Christ Church College
4 Christ Church Cathedral
5 Bishop King's Palace
6 Alice's Shop
7 Pembroke College
8 St Aldate's Church

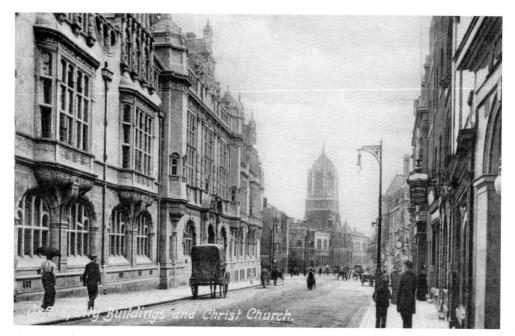

Looking down St Aldate's from the junction with the High Street and Queen's Street at the early part of the twentieth century. On the left of the picture is the Town Hall and further down is Tom Tower at Christ Church College.

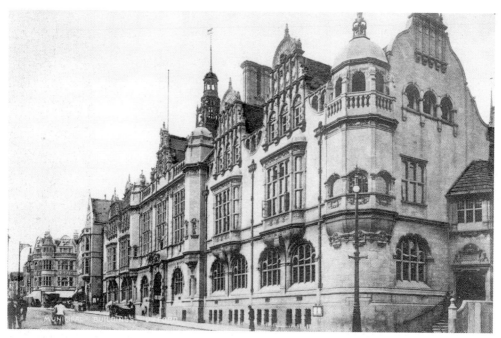

Oxford Town Hall on St Aldate's was opened on the 12 May 1897 and the *Oxford Times* on the 8 May said it 'is so funereal in aspect as to remind of a dungeon'. There was a Guild on the site from 1292 which was replaced in 1752, and this was demolished in 1893.

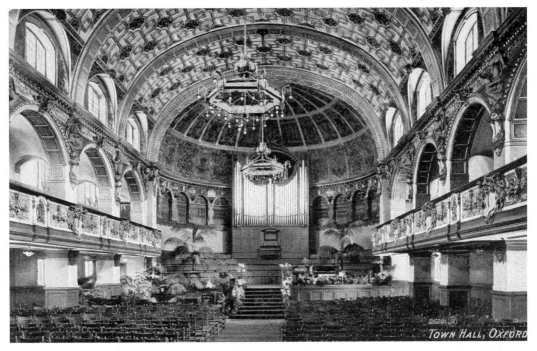

The inside of Oxford Town Hall with a Henry Willis and Son organ in the centre of the picture, installed 1896–7. The hall is rococo in style and is decorated with ornate, modelled plaster work throughout.

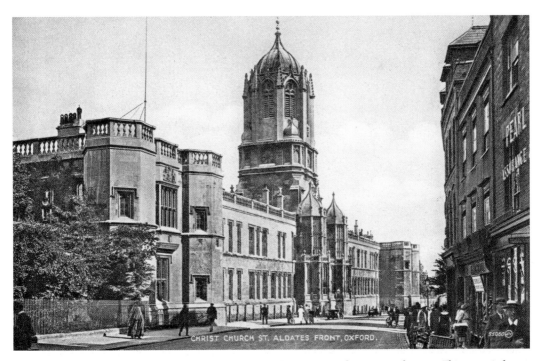

Christ Church College frontage onto St Aldate's, with Tom Tower dominating the view. This scene is from the 1920s.

Christ Church College was founded by Cardinal Thomas Wolsey in 1525 and was called Cardinal College, but after his death in 1529 it came under the wing of Henry VIII and was called King Henry VIII's College.

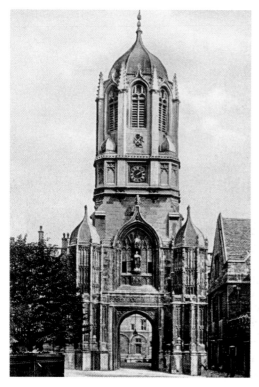

The main entrance to Christ Church College is under Tom Tower. The lower section is from Wolsey's period, with the upper section designed by Sir Christopher Wren, completed in 1682. The tower houses the great Tom Bell that rings the curfew in the evening to call the students back into the college.

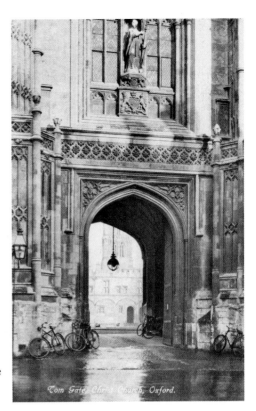

Looking through the gate into the Tom Quadrangle with a statue of the original founder, Cardinal Wolsey, by Francis Bird, above the gateway.

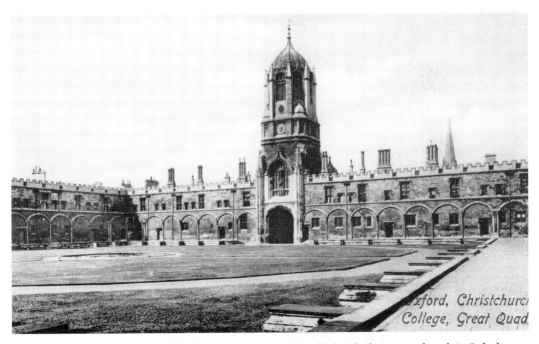

Looking back towards Tom Tower in the Tom Quadrangle, which is the largest quadrangle in Oxford. It was always intended that it should have cloisters but they were never built.

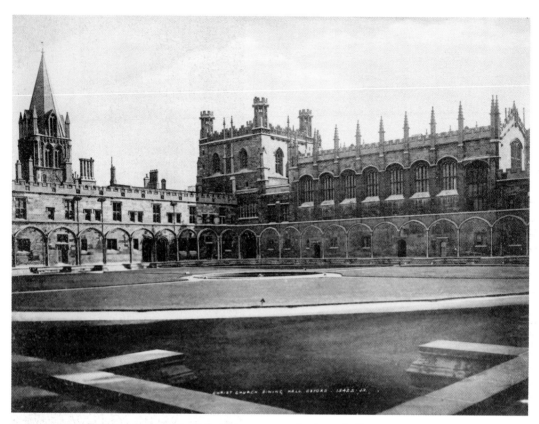

Looking across Tom Quadrangle. To the right of the picture is the dining hall, in the centre is the Bell Tower and on the left is the spire of Christ Church Cathedral. In the centre of the quadrangle is an ornamental circular pool that now has a copy of Giovanni da Bologna's Mercury at the centre of it.

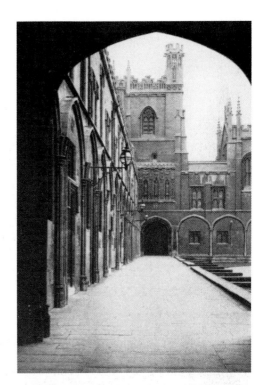

The back terrace of Tom Quadrangle. The dark archway at the end of the terrace is the entrance to the grand staircase up to the dining hall, and the Bell Tower is above it.

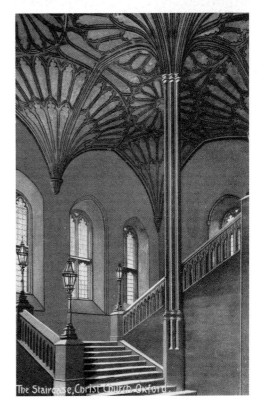

The Staircase, Christ Church, Oxford.

Looking up from the bottom of the staircase up to the dining hall. The fan-vaulted ceiling and central pier is early Gothic Revival from the seventeenth century and the staircase itself is early nineteenth century.

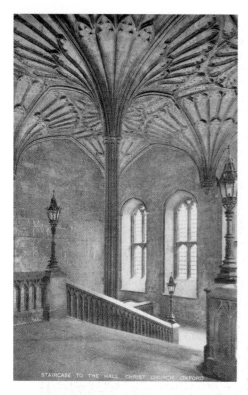

The view from the top landing of the staircase gives a fine view of the detail in the fan-vaulted roof, the work of a mason called Smith from London.

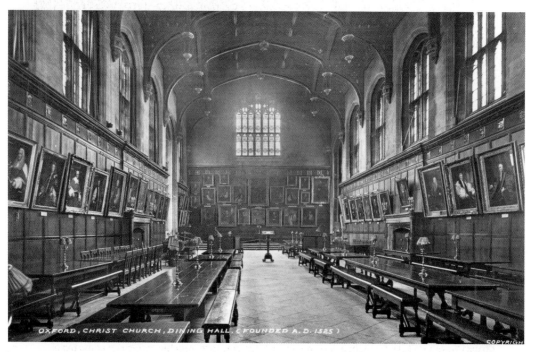

Looking towards the dais end of the dining hall with the long dining boards and forms for the students to sit on when dining. The hall was used as Hogwarts' dining hall in the Harry Potter films.

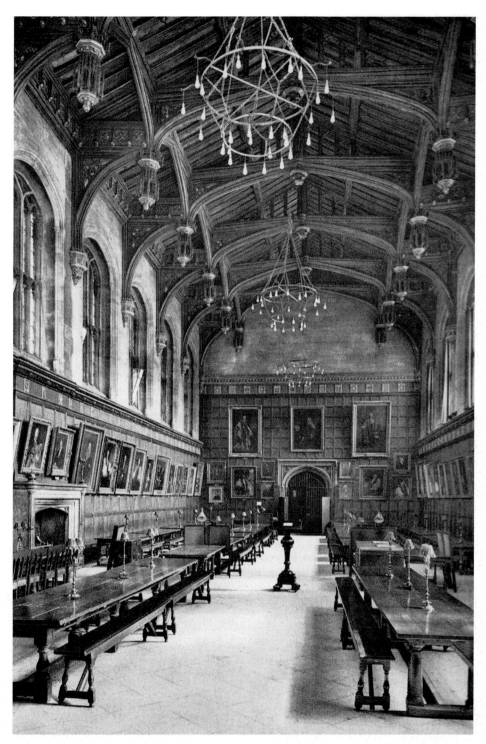

Christ Church College dining hall, looking towards the entrance from the ante-room at the top of the staircase. The roof is of hammer-beam construction and the hall is pre-Victorian, and was used by Charles I's Parliament during the Civil War.

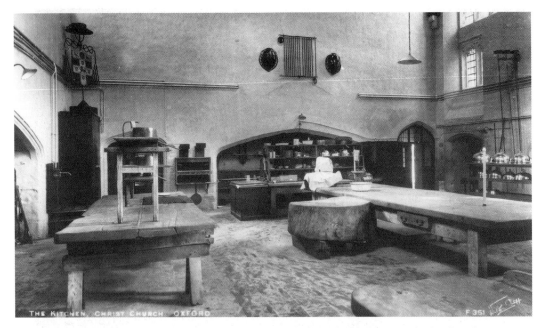

The kitchen is part of Wolsey's original building. This picture is from the late Victorian/early Edwardian period, but the Tudor cooks and spit boys would not feel out of place in it. It has three huge fireplaces for roasting and cooking on.

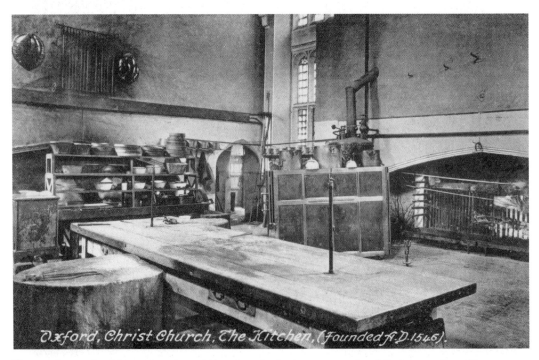

The massive wooden tables or boards would be where the food was prepared and the large section of tree trunk on the left is a chopping block. A hint of the Victorian period can be seen next to the fireplace in the form of a boiler, most likely for heating water for the washing up.

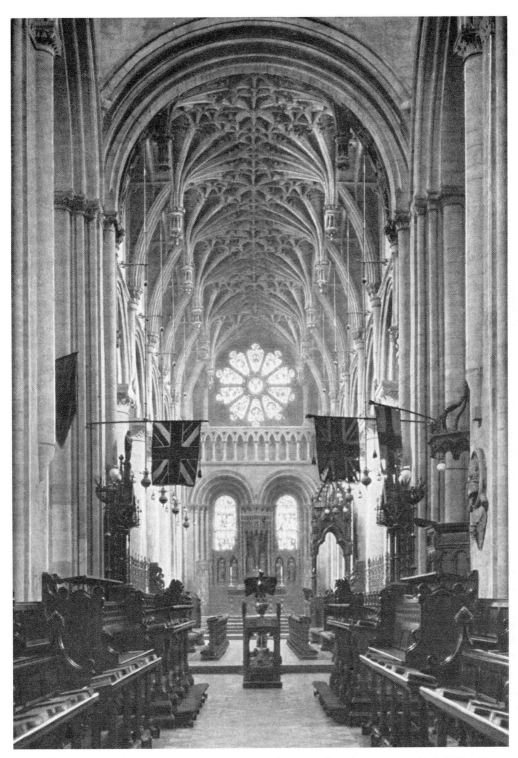

Christ Church Cathedral, located on the east side of Tom Quadrangle, was originally St Frideswide. It then became the college chapel and in 1546 Henry VIII made it the cathedral.

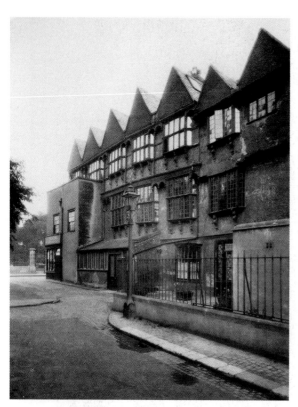

The Bishop King's Palace stands at the far end of St Aldate's Street and is believed to be the palace of Bishop King, who was the last Abbot of Osney.

Opposite : Alice's Shop is No.83 St Aldate's Street, and the little girl, Alice Liddell, who Lewis Carroll based Alice (from *Alice in Wonderland*) on, would buy barley sugar sweets from the shop. The shopkeeper at the time had a bleating voice similar to a sheep, and she and the shop became part of the story as a character and location. There has been a shop on the site since the 1830s and the building is claimed to be 500 years old. It became Alice's themed gift shop in 1965.

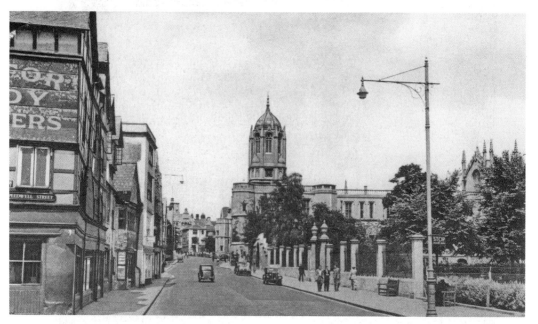

Looking up St Aldate's, back towards Christ Church College on the right of the picture and on the left, a short distance from where the picture was taken, can be seen what was to become Alice's Shop. The picture dates from the early 1950s.

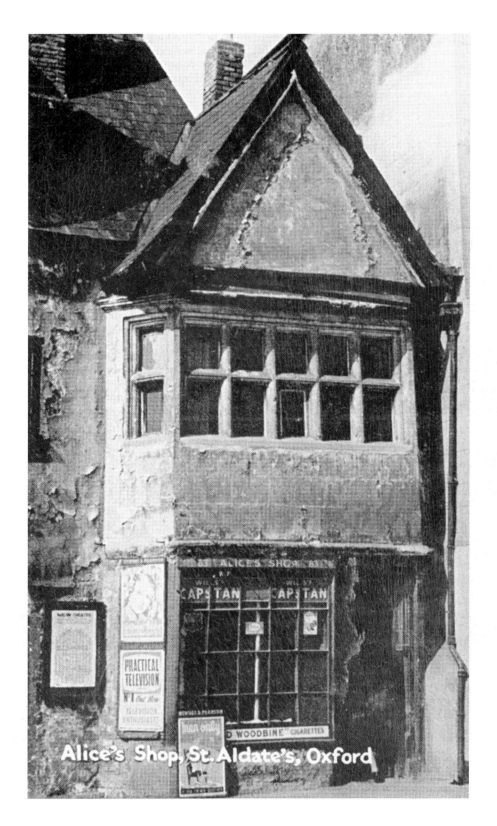

Alice's Shop, St. Aldate's, Oxford

Pembroke College was founded in 1624 by James I but Thomas Tesdale of Oxfordshire and Richard Wightwick of Shropshire put up the money. Tesdale's money had come from growing woad for dyeing. The name Pembroke came from the Earl of Pembroke, who was Chancellor of the University at the time.

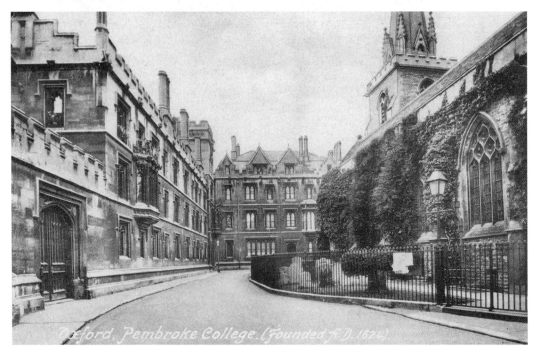

Looking down Pembroke Square from the junction with St Aldate's, with Pembroke College on the left and centre of the picture and with St Aldate's Church on the right-hand side of the square.

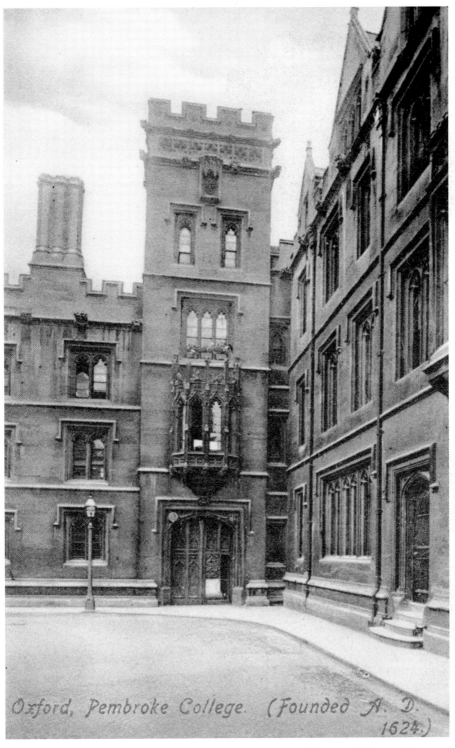

Oxford, Pembroke College. (Founded A. D. 1624.)

Looking towards the gateway tower, the doorway at the bottom of the tower leads into the Old Quadrangle. The frontage of the building is Gothic in style and dates from 1829–30.

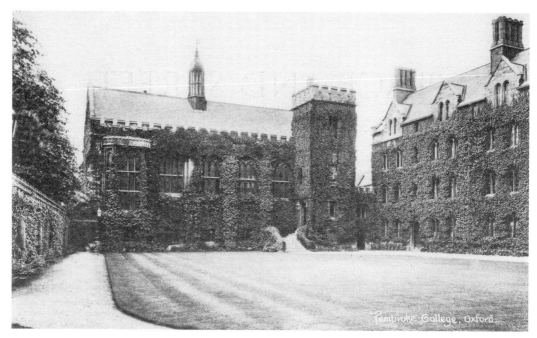

Pembroke College Chapel Quadrangle, looking towards the dining hall designed by John Hayward, built in 1848. The tower is the staircase into the hall.

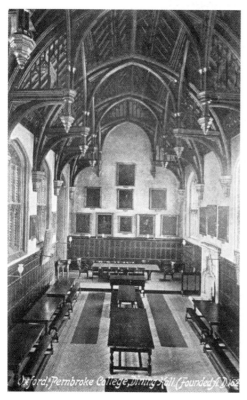

The inside of Pembroke College dining hall, looking toward the dais end of the hall. The roof, which is hammer-beam in design, is a stunning piece of the nineteenth-century carpenters' workmanship.

PLACE AND STREET INDEX

Other titles published by The History Press

The Street Names of Oxford

MARILYN YURDAN

The names of Oxford's streets and roads are fascinating and in many cases unique. This book traces the origins of names found in Oxford, not only of its streets and roads, villages, suburbs and housing estates, but also of the various colleges which make up the university, many of which have had a considerable influence on its streets. Containing illustrations that range in date from nineteenth-century prints, revealing a very different city, through to photographs of modern developments, this book is a must-read for anyone interested in Oxford's streets and development.

978 0 7509 5098 5

Tolkien's Oxford

ROBERT S. BLACKHAM

The buildings and people of Oxford were a valuable source of information for *The Hobbit* and *The Lord of the Rings*. This absorbing book charts Tolkien's life in Oxford from 1911 to 1973, using old postcards, maps and photographs to paint a picture of the places and times that relate to one of the leading authors of the twentieth century. Presented in a handy guide-book format, this is an essential companion for anyone wanting to find the places that influenced Tolkien and his work.

978 0 7524 4729 2

Curious Oxfordshire

ROGER LONG

Curious Oxfordshire presents more than 100 sights, incidents and legends from the various parts of Oxfordshire. It features the tales of unsolved murders, witchcraft, hangings, poltergeists, underground caves and passages, 'cunning men', backswording and riots. Together with a collection of rare photographs and original drawings, these delightful stories will inspire residents and visitors alike to further discover this famous and curious county.

978 0 7509 4957 6

Haunted Oxford

ROB WALTERS

Drawing on historical and contemporary sources *Haunted Oxford* contains a chilling range of ghostly accounts. From tales of spirits that haunt the libraries of the Oxford colleges and shades that sup at the pubs and watering holes around the city, to stories of spectral monks and even royal ghosts, this phenomenal gathering of ghostly goings-on is bound to captivate anyone interested in the supernatural history of the city.

978 0 7524 3925 9

Visit our website and discover thousands of other History Press books.

www.thehistorypress.co.uk